OBJECT LESSONS

ORIGINAL ART FROM GUILD ARTISTS

OBJECT LESSONS

ORIGINAL ART FROM GUILD ARTISTS

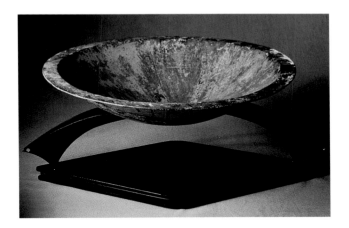

GUILD Publishing
Madison, Wisconsin USA
Distributed by North Light Books, Cincinnati, Ohio

FRONT COVER
BRIAN KERSHISNIK,
Still Life with Sleeping Musician,
24.5"H × 20"W.
Giclée print on archival paper.

BACK COVER
JACK MOULTHROP,
Spiral CB with Color Band,
15"H × 20"DIA.
Paddle-formed earthenware
vessel with interior glazing.

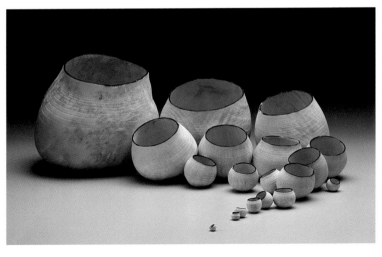

FRONTISPIECE
NORMAN FOSTER,
The Sheltering Sky (detail),
56"H × 48"W.
Oil on board.
Photo by Patrick Tregenza.

TITLE PAGE
CAROL WARNER,
The Landing,
9"H × 23"H × 17"H.
Handbuilt copper bowl.
Photo by Warwick Green.

CHRISTIAN BURCHARD, *Baskets*. Group of 19 wood baskets made of green madrone. Thin-turned, warped, bleached and sandblasted.

OBJECT LESSONS: Original Art by GUILD Artists

Copyright © 2001 by GUILD, Inc.
"Word of Mouth: On Objects of Oral Delight" Copyright © 2001 by Suzanne Ramljak

Contributors: Glenn Adamson, Karen S. Chambers,
Jody Clowes, Susanne K. Frantz, Lloyd E. Herman, Martha Drexler Lynn,
Suzanne Ramljak, Toni Sikes and Barbara Tober

Chief editorial officer: Katie Kazan

Project manager: Carol Chapin

Production manager:
Cheryl Smallwood-Roberts

Production artist: Bob Johnston

Series design: Lindgren/Fuller Design

Published by GUILD Publishing
An imprint of GUILD, Inc.
931 E. Main Street
Madison, Wisconsin 53703
TEL 608-257-2590
FAX 608-257-2690

Distributed by North Light Books
An imprint of F&W Publications, Inc.
1507 Dana Avenue
Cincinnati, OH 45207
TEL 800-289-0963

ISBN: 1-893164-11-X

Printed in China

CONTENTS

PUBLISHER'S NOTE

Toni Sikes

The objects we live with tell stories; what we must do is learn to listen. Often their stories are told in the faintest of whispers, through fragments of explanation and flashes of illumination.

The objects become our preface. They speak to us; they move us. We take them home and live with their story and add our personal embellishments along the way.

The works of art found within the following pages speak volumes, and it is up to each of us to seek the lessons offered. We invite you to lean forward and listen a little harder

OPPOSITE
Jamie Robertson, *Media Cabinet,* 63"H × 51"W × 24"D.
Cabinet carved from limewood, mahogany and holly and
painted with a trompe l'oeil facade. Photo by Robertson & De Rham.

THE NOBILITY OF BEAUTY

Barbara Tober

*"Every year of my life I grow more convinced that it is wisest
and best to fix our attention on the beautiful and the good,
and dwell as little as possible on the evil and the false."*

— Richard Cecil

There is something noble in the pursuit of beauty now. A kind of "in-your-face" ugliness and violence are fashionable in the art world, and conscientious objectors are made to feel out of step with the times. This phenomenon seems to coexist with the population explosion, the throbbing rhythm of our cities and the decline of nature as forests, plains, wild animals, exotic species and ocean creatures not so slowly disappear. We — Homo sapiens — are the juggernaut. And how frightening that as we prevail, our desire for aesthetics — if that be the correct term — echoes the worst of our culture. "What is art if it doesn't shock . . ." said one young viewer at a recent X-rated exhibition in New York. And indeed that is the attitude of many patrons of contemporary works that include offensive installations, disgusting videos and other noisome manifestations of the current mode.

Yes, one can argue that much of religious art has been brutal. Certainly the countless images of St. Sebastian are archetypal, as are so many tales from the Bible meant to set a terrifying example for those who would transgress. Centuries of war have been glorified by gallons of paint and tons of bronze in order to instill a sense of awe and duty as the mighty and their minions battled one frontier against another in an agrarian age. But violence doesn't seem to end with war, as we court vicarious thrills today in film and video games and on canvas, paper and any media we can utilize. We are addicted — in living Technicolor — to the daily reenactment of our wildest nightmares.

Is there surcease? Luckily, yes! For an increasing number of collectors and art lovers, the world of nature, of form and function, of pleasing and evocative shapes and colors — which can range aesthetically from calm to

OPPOSITE
Elizabeth MacDonald, *Landscape*, 40"H × 40"W × 1"D.
Ceramic tile created by layering ceramic powders on thin pieces of
textured clay. Photo by Bob Rush.

exciting — not only exists but beckons. There are artists living today, in America and around the world, who have in their mind's eye and in their hands and hearts the ability to bring us to joyful tears. To see Dale Chihuly and his colleagues, such as Lino Tagliapietra, and their apprentices create great glistening chandeliers, "Venetian" vases, seaforms and the like from simple rods of glass in a red-hot furnace is to watch one of life's greatest dramas in crafts-manship. Equally impressive are the sculptures by William Morris, whose blown and pâte de verre reflections of the ancient world are treasures that can partner antiquities with dignity and grace.

How moving it is, too, to witness a potter smooth clay on a wheel with the deft hands of a dancer, or ceramists, such as Bennett Bean or Michael Lucero, build graceful sculptures that are timeless yet utterly new in concept and execution. Let us also applaud the talents of the Moulthrops — father and son — for whom wood is the muse. Their signature forms in polymer-infused woodgrains have a fluidity and a tactile quality that raises tree-hugging to new heights. For these and other artists of their ilk, every millimeter of a tree's growth over time is a signal for his or her expertise — molding and integrating the whorls, burls and natural colors into disciplined and exquisite forms that become museum-quality collectors' treasures.

Starting with the earliest stone tool, we have the first craftsman and the first entrepreneur. He (probably male, for prehistoric females had their own problems) made an object that — by virtue of the barter system — enabled him to earn food, water, and perhaps shelter. Just as it has been for centuries, metalwork in all its diverse forms is art — from Albert Paley's gates of grandeur for a university, to the miniature sculptures by artists such as William Harper, Andreas von Zadora and Michele Oka Doner that

we collect as contemporary jewelry. These wearable art forms are growing in demand because they are imaginative, unique, fluid and appealing in their artistry . . . and body friendly.

Textile or fiber art — how ancient is this field with its historic tapestries and quilts, mummy wrappings, Greek and Roman fragments, gilded Peruvian wall panels that are echoed by artist Olga de Amaral, woven fantasies and textured wall sculptures from all over the world. Fiber art pieces made now, such as those created by Sheila Hicks, can soften and humanize the most contemporary spaces. Fiber art includes the making of paper sculpture in sensual and compelling new textures, mixed media, and a plethora of feathers, beads, twine, leaves, twigs and the like. These "paintings" without paint, "Spirits of the Cloth" as we called them at the American Craft Museum, can reward us with a lifetime of visual pleasure.

Building a collection of beautiful objects is both an exciting adventure and an exercise in connoisseurship. One begins slowly, finding something graceful or charming that is pleasing to look at. Perhaps one meets an artist, seeing him or her at work, enjoying the fruits of this meeting for their aesthetics as well as the connection and the memories. As the collection grows, other factors enter

YOSHIKO YAMAMOTO, *Facade*, 2"H × 1.25"W × 0.25"D. Mustard opal set in a textured 20K gold brooch with two carnelian gemstones.

in. Books, articles, lectures and symposia stimulate awareness of the craftsmanship behind the object, the cultural significance, the rare or precious materials, the almost unbelievably difficult process that brought this or that object into the world. Some of these works of art are so emotionally compelling that one catches one's breath when seeing them. Yet for the knowledgeable collector with an "eye," the search becomes an intellectual exercise as well.

That's when the real passion for collecting begins . . . along with a philosophy. For my husband and me, the philosophy is the continuum of man's awesome ability to create beautiful things. We juxtapose an early Greek rhyton of an exquisitely shaped ceramic bull's head with William Morris's powerful minotaur. We hang Kiyomi Iwata's giant "pillows" of gold-and-copper-leafed metal mesh on the wall behind a sofa heaped with its own fluffed-up squares of chintz. One of Chihuly's famous Venetians, a huge vase of coils and silver-spangled lilies, which we watched being made at UrbanGlass in Brooklyn, sits between two Grinling Gibbons carved and gilded wood swags — fruit and flowers in deep relief. Both have the same exuberance, but they are some 250 years apart in time.

Our proclivities tend toward figurative work, so wit and humor also enter the picture. The early Sichuan "entertainer" in terra cotta, his (now lost) stick poised to beat his drum dances in the foyer, while Lucero's *Woman as Vessel* holds her "head" high in the living room. A bronze airborne dancer leaps below a watercolor of fruit and flowers. Vases for flowers are often works of glass art

GEORGE WESTBROOK, *Stone Vessel*, 3.5"H × 5.5"DIA.
Lathe-turned alabaster vessel with an African wonderstone rim.
Photo by Kevin Shields.

themselves, doubling the impact of the arrangement. The apartment is a tribute to the history of craftsmanship. And there are books piled everywhere attesting to the skills of this or that artist. No wonder we love being there . . . and other people do, too.

There are many ways to bring beauty into your life, and our culture has the ability to provide them — at all price levels. Beautiful food, clothes, interior decorations, even penmanship, speech, a pleasing voice, good manners . . . these constitute an elegance and a joyous aesthetic to which many aspire. Art is simply the next step, and the beginning of a lifelong journey of visual pleasure and rewarding relationships.

Barbara Tober is chairman of the board of governors of the American Craft Museum in New York. She also serves as president of Acronym, Inc., a venture capital firm that invests in craft-related projects, and she funds educational arts projects for children nationwide through her foundation. Prior to her career in craft art, she worked in the advertising and magazine world, serving as editor-in-chief for *Conde Nast's BRIDE'S Magazine* for almost 30 years.

INTRODUCTION

GLENN ADAMSON

It's easy to fall in love with an object. Perhaps it happens to work perfectly for your body — a chair that fits your frame or a cup handle that meets the curl of your fingers just right. Maybe the object has a sentimental meaning for you, or maybe you just think it's beautiful. All of us experience these connections routinely, so much so that we tend not to think about them much. And that's too bad. For these intense relationships between ourselves and objects can be a powerful way to learn, every bit as enlightening as our relationships to other people.

This book was designed, first, to showcase objects that have the power to provide such insights. But it also has a secondary purpose: to give some great writers the opportunity to consider the attractions and potential of objects in an unusually general way. Most essays written in the field of craft and art criticism tend toward the specific: they are studies of particular exhibitions or artists. The essays in this book, by contrast, are quite wide-ranging. Each of the six writers was asked to select objects from the website of GUILD.com and then craft an essay around his or her collection of choices. Under the encompassing rubric of "Object Lessons," the six contributors arrived at very different approaches. As editor, I have taken the liberty of organizing these disparate essays into three thematic pairs: social value, narrative content, and functionality. These strike me as the most important (if not the only) categories that we might use in analyzing our relationship to the handmade objects around us.

The first pairing combines an essay by glass expert Susanne Frantz with one by Jody Clowes, a specialist not only in contemporary craft but also in older American decorative arts. Both authors investigate the role that handmade objects play in the larger society. Frantz considers the crucial, but frequently overlooked, distinction between the professional "handmade" object and the domestic "homemade" one. As she demonstrates, this line is important to a historical understanding of the development of fine craft. It also has an impact on the

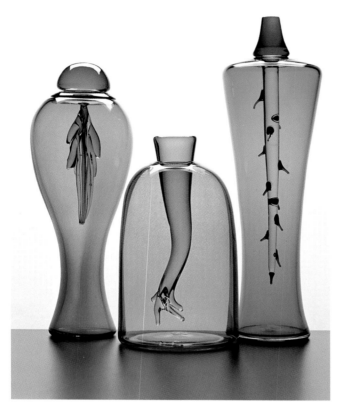

JOHN CHILES, *Organic Bottles,* 9.5"H to 11.5"H. Blown glass bottles with stoppers.

Renwick Gallery in Washington, DC, tackles the thorny issue of narrative imagery and its emotional resonance. Martha Drexler Lynn, who spent ten years as a curator at the Los Angeles County Museum of Art, addresses the equally broad topic of artistic reference to cultural or natural source material.

The final pair of essays centers on use: the way that function serves to link our minds and our senses to the things around us. Karen Chambers focuses on a particular furniture form, the chair. She finds it to be a rich format for physical and psychological engagement, particularly in the social relationships between people that seating furniture can suggest. For the objects in her collection, she has chosen not only chairs, but also images and objects that resonate with the notion of the chair, through either their content or their material. Suzanne Ramljak's essay employs the theories of Freud and other thinkers to discuss what she calls "oral objects" — things we touch directly with our mouths. Ramljak argues that this category of functional forms provides some of our most intimate and personal connections with the inanimate world.

As varied as these writings may be, they offer one thing in common: new ways of thinking about objects, and the lessons they have to offer. Each essay, read in conjunction with the images in each author's collection, suggests a single avenue between art and ourselves. Hopefully, this book will only be a prompting for its readers: by suggesting a few ways to think about the things around us, it may open up a whole world of insights.

culture of gift exchange that drives the making and selling of handmade objects. Clowes's essay is a paean to the social and personal values of the handmade. As an antidote to a world increasingly characterized by sameness, she champions the imperfection and individuality of the contemporary crafted object.

The next two essays embrace two distinct forms of content: narrative and reference. Both writers in this section are veterans of the museum world, which perhaps accounts for their interest in subject matter — curators commonly tie very different artworks together through the connecting of threads of shared content. Lloyd Herman, who was for a long time the director of the

Glenn Adamson graduated from Yale University with a doctorate in art history; his studies focused on the history of post-World War II craft. As a curator at the Chipstone Foundation in Milwaukee, Wisconsin, he teaches at the University of Wisconsin-Madison and organizes exhibitions for the Milwaukee Museum of Art.

THE GIFTS WE GIVE
HANDMADE, HOMEMADE & OTHERWISE

Essay and Collection by Susanne K. Frantz

People like to give and receive gifts. We exchange objects for a multitude of reasons and use them to commemorate almost every milestone in our lives. Births, weddings, anniversaries, retirements, friendships and holidays are celebrated with anything from a sentimental token to a lavish gesture. Selecting and giving a gift is part of the little dance that establishes ties between individuals.

The thoughtful giver considers the likes and dislikes of the intended recipient and searches for just the right thing. Choosing a gift is more than an act of generosity; it speaks of our own taste and is a reflection of the qualities we rank most highly.

Objects made by hand are traditionally at the top of the gift-giving chain of desirability. It goes without saying that until relatively recent industrial history, all gifts were handmade because everything was handmade. Nevertheless, a distinction has long been made between items fabricated by professionals versus nonprofessionals. Gifts made by and for people who know one another have special value, although they may lack exceptional craftsmanship or the preciousness of a costly material. Even today, the association of "homemade" gifts with domesticity, family and women's work assigns them (often unfairly) a humble status.

A gift made at home is invested with importance because of the relationship between the maker and the recipient. Dolly Parton sings of her family's poverty and the beloved "Coat of Many Colors" pieced by her mother from fabric scraps. The appearance of the coat — whether lovely or crude — is irrelevant, because its true power is as a symbol of the feelings shared by mother and daughter.

An object made by a professional (who is usually a stranger) conveys a somewhat different kind of meaning. Like Parton's coat, a couture gown is sewn by hand; yet, because it is designed and fabricated for hire, it is deemed "handmade" rather than "homemade." Its value as a gift, still meaningful and intimate, comes from stitches applied to exquisite textiles with the highest available skill and procured at a significant price. The accomplishment of the piece is not limited by the imagination or manual dexterity of the giver — it is better than we can make ourselves.

Such clinical distinctions are quite slippery. Determining who qualifies as a professional is debatable when anyone is free to call himself or herself an artist. Also, the position of homemade is not immobile — it can be bumped up to handmade when the object is of such age, rarity or quality that it transcends its amateur origins. Exceptional gifts that are made at home and then handed down from generation to generation assume a new cachet when offered for sale in a gallery or antiques shop. Ironically, once an object becomes acceptable for

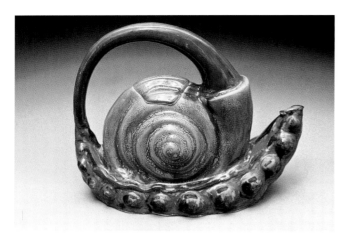

JARED JAFFEE, *Snailing on a Sea of Peas Teapot*. The vessel can be as enigmatic and challenging as any other sculptural format. This example has its roots in folk tales, surrealism and historic European ceramics. It brings to mind the symbolic and startling couplings of natural forms produced toward the end of the 19th century by potteries in Nancy, France. Photo by Jared Jaffee.

strangers to give or receive, the homemade stigma is shed.

Although the word "crafts" has now supplanted the term "decorative arts" for anything handmade and marginally useful, in the past the two were quite different fields. True crafts were humble items made to work. Today, in industrialized countries, real crafts (not items made for tourists) are quaint oddities. In the Czech Republic, where I live, one can occasionally see an elderly lady standing on a street corner and selling meat basters made from goose feathers. By plaiting the quills together, she creates a perfectly useful item — a craft object. As attractive as they are, the inexpensive basters are not put on display nor are they given as gifts. They are intended to be used until worn out, then discarded. That is precisely what most crafts used to be, but are no longer. The plain truth is that plastic tubs are sturdier than woven baskets or clay pots.

In essence, modern crafts have only two real jobs — to make our surroundings more pleasant and to serve as special gifts. In this regard, they perfectly fit the traditional definition of the "decorative arts." Crafts are no longer the tools of rugged daily use. Like all decorative arts, they are prized for their pleasing appearance, complex and remarkable workmanship, and the status that they confer upon the owner. Stories abound of the vast resources dedicated to the development and protection of the processes for making such treasures as Venetian *cristallo* and Meissen porcelain. Even after the introduction of mechanization capable of producing high-quality goods, only a few industrially produced items ever came close to rivaling the prestige of an exquisitely handcrafted object. At the height of its mid-20th century domination of international technology, the American government routinely commissioned handmade blown and engraved Steuben glass from upstate New York as the preferred gift of State.

Over the past forty years, as more and more students have graduated from integrated art and craft educational programs, and as the home furnishings market has boomed, fine American handmade objects have become readily available to the general public via specialized shops and galleries, mail order catalogues and — now — the Internet.

For American glass, the post-World War II period yielded remarkable progress in the quality of the average

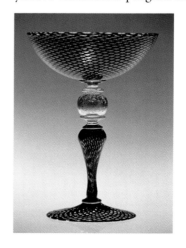

PETER GREENWOOD, *Black Lace Goblet.* Greenwood excels at traditional glassblowing techniques such as the net-like Italian *reticello* (a filigree of twisted lengths of colored glass interspersed with minute air bubbles). While this goblet echoes its elite 17th century predecessors, the color palette and proportions place it firmly within a contemporary context.

decorative object. It has come a long way from the pressed glass animals of the 1940s and 1950s, and the artsy-craftsy stretched-out soda pop bottles of the 1960s. It is still possible, however, to find inferior pieces promoted as worthwhile simply because they are made by hand. Sometimes a misguided interpretation of the Oriental appreciation for natural forms, the imperfect and the accidental is used to excuse substandard workmanship. A clumsy object is not redeemed by the fact that it was manufactured in a small studio rather than a factory. Unless they are clearly conceived as nonfunctioning sculptural objects, teapots should pour evenly, wine goblets should stand straight and feel comfortable to the hand, vases should be stable and scent bottles should seal tightly. No matter how timeless, designs should not slavishly replicate those of the past unless they are presented as reproductions. Slight irregularities are inevitable, and all aesthetics build on what came before — but for handmade objects to remain vital, they must be both excellent in execution and original in conception.

Why would anyone desire a handmade object today? Quite simply, crafts as decorative arts will always have a place in our surroundings because they are com-forting. Their forms and textures remind us of ourselves; they are our size, we wear them and we sit upon them. A smooth, curvaceous shape feels good in the hands. Humans gravitate toward the container and the naturally hollow shape of wheel-thrown ceramics and blown glass. Our bodies, like the bodies of vessels, enclose spaces; pitchers have lips, goblets have waists and feet. We associate bowls, cups and boxes with food and drink and ceremonial events, and thus, pleasant memories.

Perhaps subconsciously, the veneer of practicality and the historic relationship to domestic work help to keep the crafts accessible and inviting. At their best, craft objects are rich, but not pretentious. They are unashamedly beautiful — designed to please rather than provoke. They provide a counterbalance to the advanced technology that is part and parcel of our lives. While we demand reliability and performance from the microchip, crafts are expected to remind us of human individuality and creativity. They declare that the buyer still values such

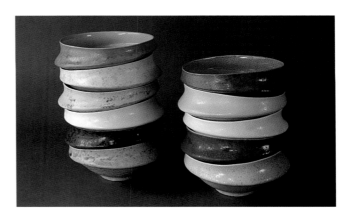

KAETE BRITTIN SHAW, *Bowls*. Givers of the decorative arts have never selected objects based on their practicality alone. The smooth interiors of these bowls and their essential balance do indeed make them perfectly functional. However, what draws us to them is their beautiful quirkiness: the creased and pinched asymmetry, the unusual mottled glazes and the concertina shape of the stacked forms. Photo by Kaete Brittin Shaw.

qualities and believes that the recipient will as well. Handmade objects are personal and their exchange speaks of meaning beyond an empty ritual of behavior. It is for good reason that we give vases, not cell phones, as wedding gifts. We probably always will.

Susanne K. Frantz was the curator of 20th-century glass at The Corning Museum of Glass in New York for thirteen years before relocating to the Czech Republic as a Fulbright senior scholar in 1998. Her book *Contemporary Glass: A World Survey from The Corning Museum of Glass* (Harry N. Abrams, Inc., New York, 1989) remains a primary reference in the field.

ROBERT KEHLMANN

Palermo, 1996, 20.5"H × 27.25"W × 1.25"D. Blown glass, cut by hand, and mixed media on Masonite. Photo by Richard Sargent.

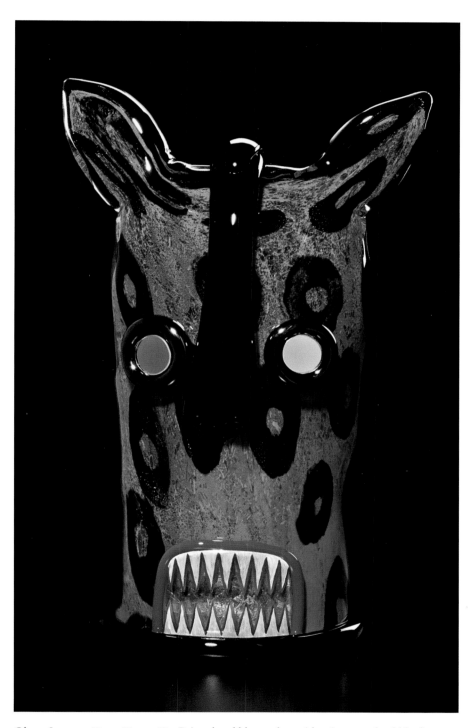

Olmec Jaguar, 16"H × 8"W × 6"D. Painted and blown glass with mirrors and gold leaf.
Photo by Roger Schreiber

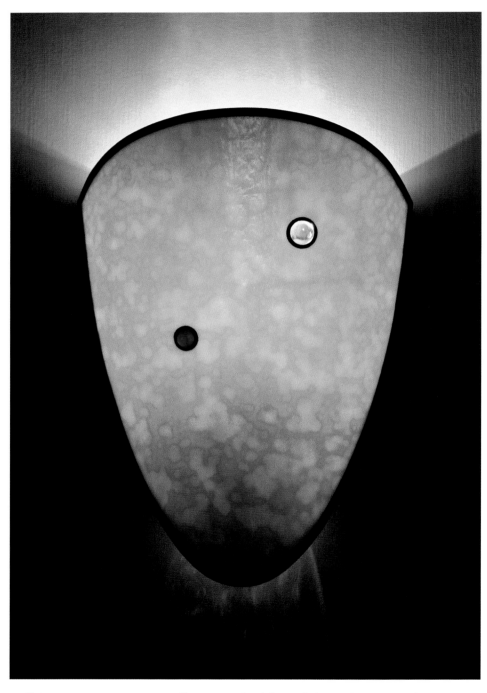

Wall Sconce, 13"H × 9"W × 5"D. Wall sconce made of slumped glass with inset glass elements.

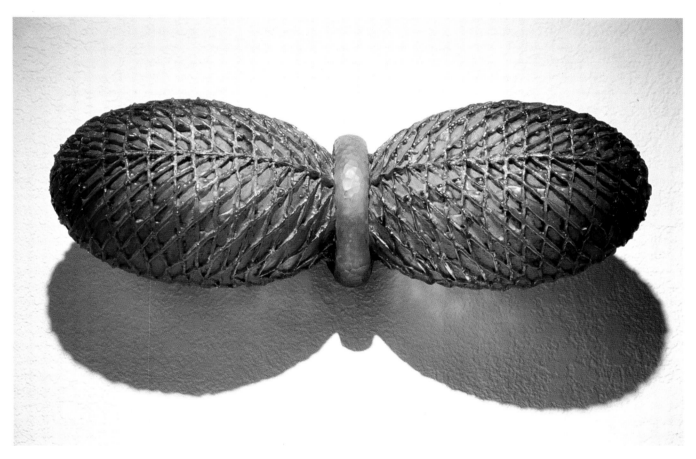

Pleat, 6"H × 16.75"W × 7"D. Cast glass sculpture, acid-etched and painted with ink. Courtesy of Elliott Brown Gallery.

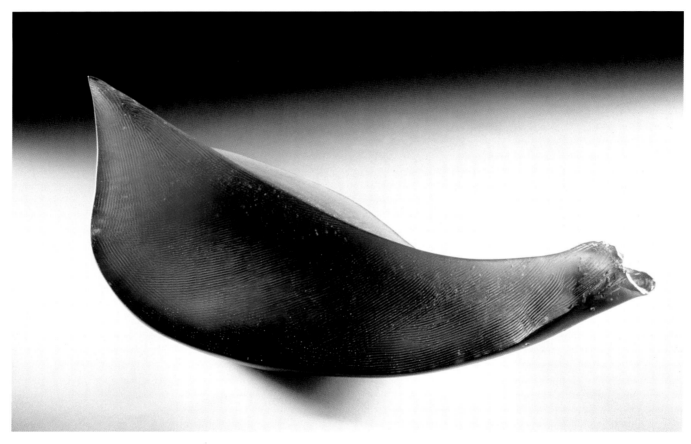

Drift, 1999, 8"H × 19"W × 11"D. Cast lead crystal sculptural form. Courtesy of Elliott Brown Gallery.

ANTHONY CORRADETTI

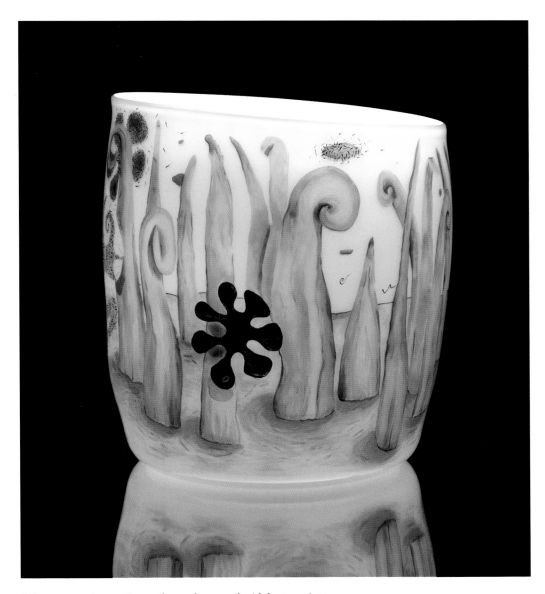

Microscape, 17"H × 16"DIA. Blown glass vessel with luster paints.

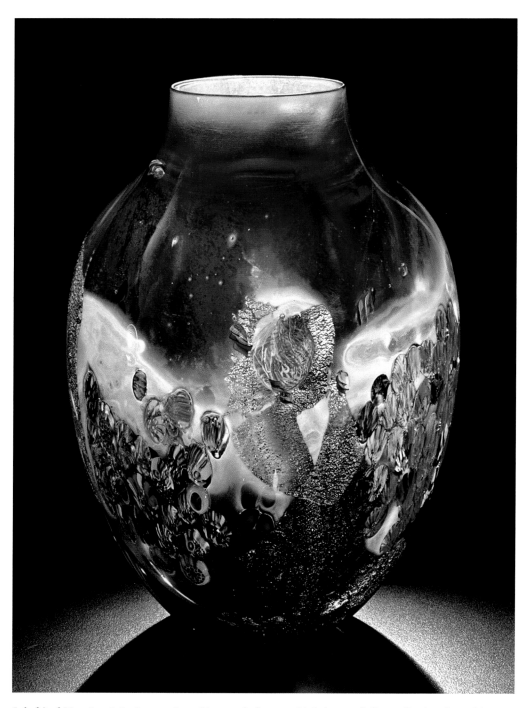

Inhabited Vase 6.1.98, 8.5"H × 5.5"DIA. Vase made from multiple layers of silver reflective glass with flame worked inclusions. Photo by Tommy Olof Elder.

Reflection Pool Earrings, 1"DIA. Cast sterling silver earrings set with red crystal glass.

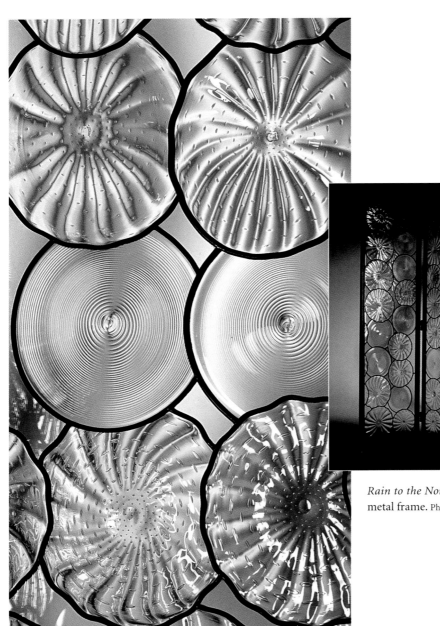

Rain to the North, 84"H × 120"W × 1"D. Leaded glass screen in a metal frame. Photo by Russell Johnson.

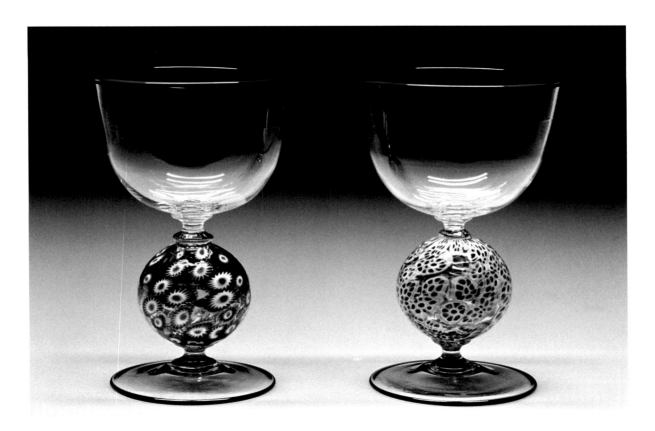

Murrini Ball Goblets, 6"H × 4"W × 4"D. Blown glass goblets with stem composed of murrini.

Cornflower, 6.5"H × 2.75"w. Glass perfume bottle with reticulated, forged and finished sterling silver and hand-carved Micarta finial. Photo by Ralph Gabriner.

Brooch, 1.75"DIA. Glass cut by hand from antique bottles, etched and set in textured sterling silver. Photo by Hap Sakwa.

Marquiscarpa #97-9, 1997, 7.5"H × 8.25"W × 4.75"D. Cast, blown, slumped and assembled glass sculpture made from hundreds of handmade murrini. Courtesy of Elliott Brown Gallery.

KATHLEEN ASH

Chiware, platter (18"w × 9"D), boat bowl (3"H × 19"w × 8"D), bowl (14"DIA), square bowl (4"H × 14"w × 14"D). Fused glass bowls and platter with etched Chinese designs.

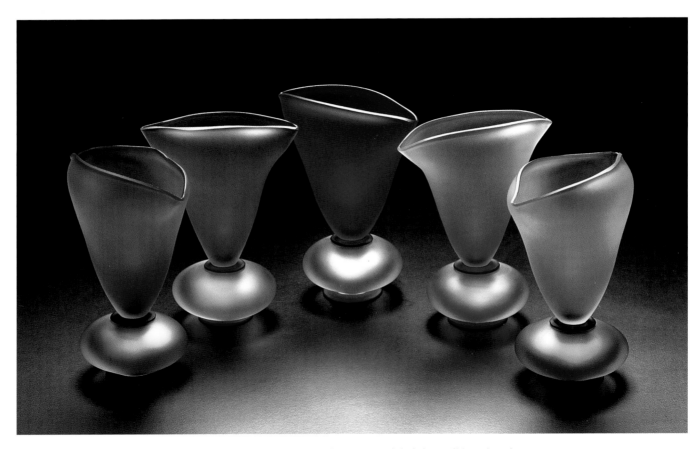

Flat Ball Vase, 9"H × 4"W × 4"D. Blown and carved translucent glass vases with lightly sandblasted surfaces. Photo by Don Pitlik.

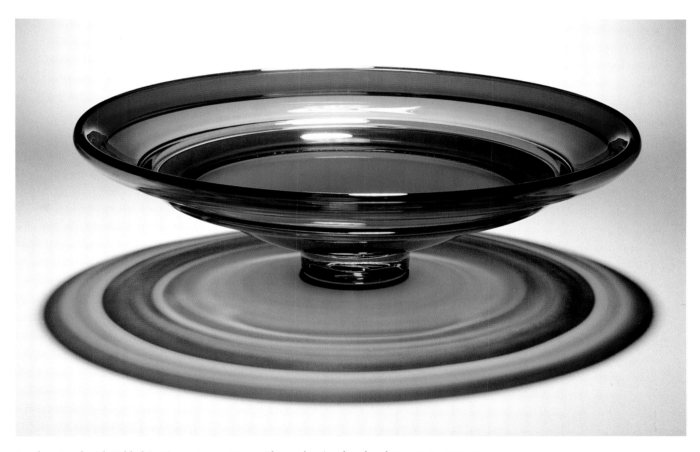

Incalmo Bowl with Folded Sections, 4"H × 16" DIA. Blown glass incalmo bowl. Photo by David Kingsbury.

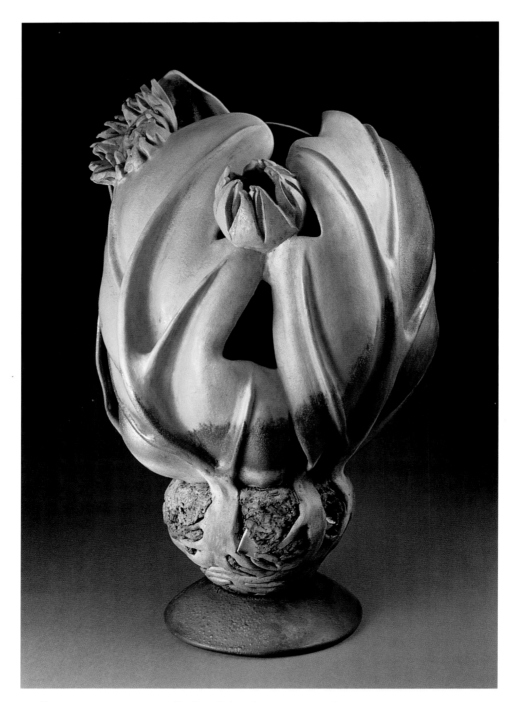

Sunflowers, 24.5"H × 15"D. Handbuilt and glazed terra cotta vessel. Photo by Linda Huey.

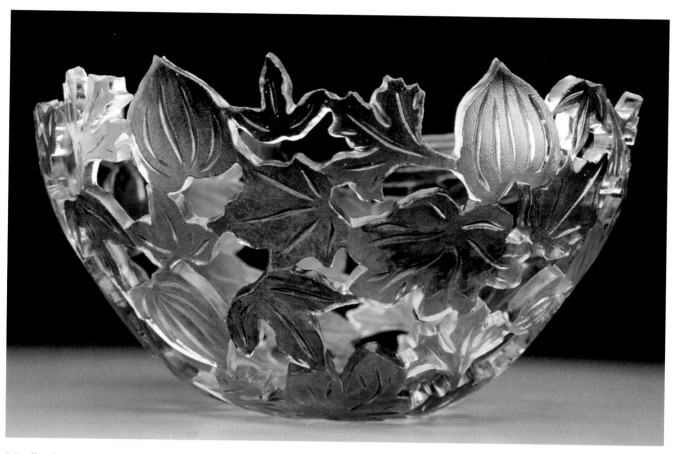

Woodlands, 6"H × 7"DIA. Blown and carved glass bowl with handpainted and fired-on colors.

Vase, 19"H × 11"W × 11"D. Stoneware vase of handbuilt and coiled construction.

Fruit Plate, 1"H × 12.5"DIA. Wheel-thrown white stoneware plate. Surface drawings are created with underglaze pencils, lusters and china paints.

He/She Teapots, He (6.5"H × 7"W × 4"D), *She* (6"H × 8.5"W × 4"D). Functional cast terra cotta teapots. Courtesy of Ferrin Gallery.

Blade Back, 20"H × 12"W × 9"D. Sculptural figure made from terra sigillata. Photo by Charlie Frieburg.

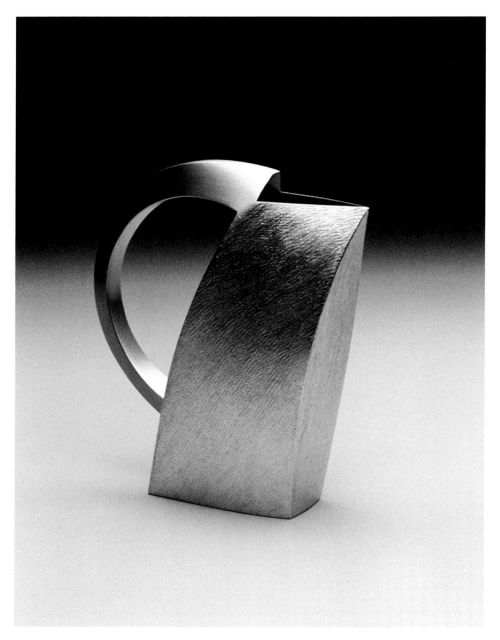

Wedge Pitcher, 8"ʜ × 6.5"ᴡ × 2.5"ᴅ. Pitcher of spun and constructed pewter with a textured finish. Photo by Ron Bez.

BRUCE MACDONALD

Mantas Salt and Pepper, 2.5"H (each). Functional salt and pepper shaker set made of stainless steel, brushed by hand. Photo by John Goodman.

Diamond Bowl, 3"H × 20"DIA. Bowl made of fused, slumped and layered glass with details drawn by hand.

Five-Square Bowl, 2.5"H × 16"DIA.

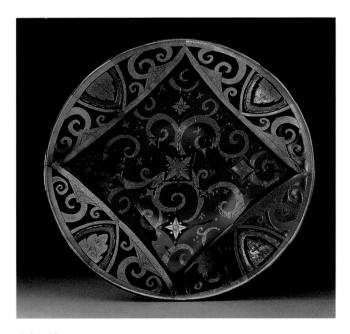

Celtic Sky, 2"H × 20"DIA.

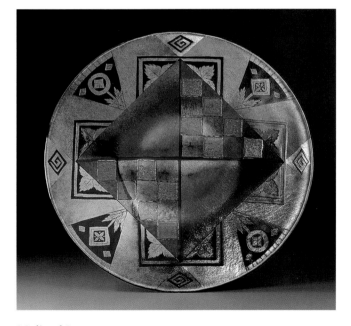

Medieval Pageantry, 2"H × 20"DIA. Photos by John Polak.

Mountain: At Night, 17"H × 9.25"W × 5.5"D. Blown and acid-etched glass vase.

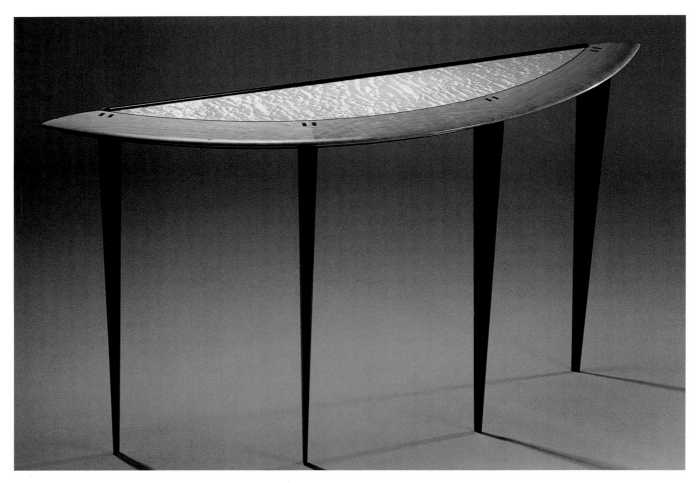

Bow Table, 32"H × 54"W × 14"D. Table with quilted maple and cherry wood top, with ebony inlay. The legs are handcrafted of ebonized mahogany. Photo by KC Kratt.

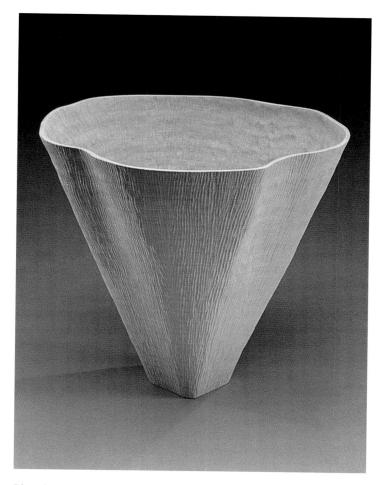

Pine-Cone, 18"H × 18"W × 18"D. Large sculptural bowl of carved and laminated white pine with laquer finish. Photo by John Phelan.

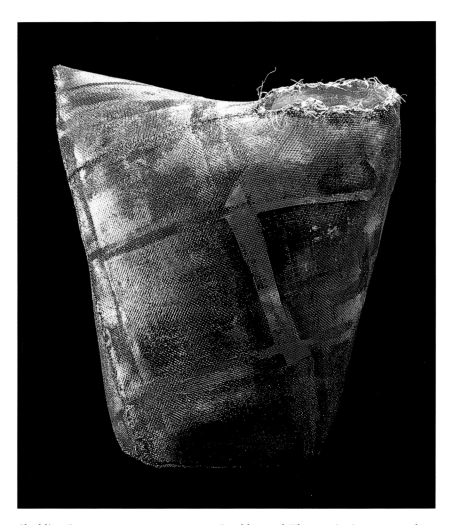

Shedding One, 1998, 14"H × 10"W × 11"D. Double vessel. The exterior is constructed of aluminum mesh with composite gold leaf. The interior is a stiffened-silk bag.

Photo by D. James Dee.

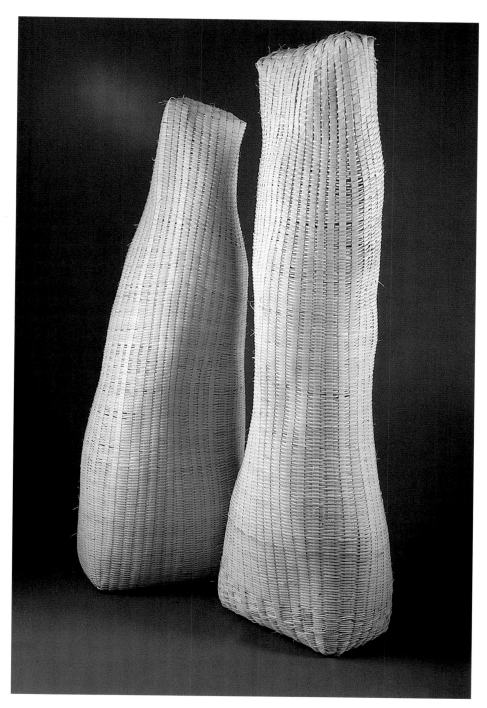

Untitled, 68"H × 24"W × 18"D; 72"H × 24"W × 18"D. Large-scale handwoven reed objects.
Courtesy of R. Duane Reed Gallery.

THE SOUND OF ONE HEART POUNDING

ESSAY AND COLLECTION BY JODY CLOWES

Here in the richest country in the world, we are inundated by stuff. Children's rooms bulge with underused toys, stylish kitchen gadgets jostle for counter space, and last season's fashions are swiftly routed to the resale store. Sure, it's fun to shop, but there is a price.

Having all those things demands time, energy and attention. Just wading through the onslaught can be over-whelming. Cool stuff, fun stuff, useful stuff, junk . . . so many judgments to make! So many choices! So many needs you hadn't recognized! Even if you're not a recreational shopper, stuff has a way of appearing on your doorstep. Other people give you things — things you might never have chosen but feel obligated to use and display.

You could throw everything out and begin again. But even this offers its own stresses. Simple living has lately become a fetish, and fashionable asceticism requires strict discipline. Glossy magazines declare the virtues of paring down, and then ravish you with fantasies of lusciously spare, tranquil rooms. Glowing with natural light, pure linen, pale flowers and just a dab of stainless steel, these ethereal spaces belong to tasteful, delicately sensuous, ruthlessly selective people. If, like me, you aren't so tastefully discretionary — or so dedicated to cleanliness

and order — this kind of living is not simple at all. Besides, I'm not naturally austere. I like objects. I like living with things that tangle with my eyes in the morning and arrest my fingers at night. I don't want to throw everything out or live in a serene white box. I don't want a lot of things, and I don't want the noisy junk I buy when I'm not paying attention. But I don't want the "right" things, either. I want things that excite me.

The trick is finding out what those things are. It isn't easy to look at things while treading water in a sea of manipulative advertising. The loud, bright, brittle din of the shopping mall is distracting and confusing, and the constant flow of shallow information is wearing. You can learn a lot about seduction in the mall and on television. But if you want to find out what really makes your blood pump, you have to slow down and attend to things. You have to give yourself over to them, and that takes time.

I've taken some time to ponder this. I've found that my heart pounds loudest for things that speak of work, and pulse with the energy of their creation. Just as too

OPPOSITE
MYRA BURG, *Quiet Oboes with Twigs and Jute* (detail), 2000, 2"DIA to 5"DIA. Wrapped fiber, twigs and jute.

49

LIZ AXFORD, *Mumbo Jumbo 3* (detail). The craftsperson works by trusting the process — in this case, piecing and quilting — and engaging in an ongoing dialogue with materials and techniques. Photo by Hester & Hardaway Photographers.

many of us work for other people's goals, fueling the economy without feeding our souls, too many objects speak only of efficiency, uniformity and empty seduction. Self-directed, searching work is a rare treasure, and the objects that emerge from such work are almost as precious. They remind us how we might live — how we should live, if we are able. The best of them are imbued with focus and dedication, shining with the excitement of discovery.

Mass-produced things can shine in this way, I know. My old prejudice against plastic has crumbled in Philippe Starck's hands. I have steel spoons that fit perfectly within my mouth, and garden shears that sing in my hand. My neighbor's snowboard glistens with speed and pure ambition, and I lust after a certain porcelain sink. In these objects, I can sense a designer's pleasure, and the delight that bubbles up with the solution of a complex problem. Using them (or even wanting to use them) offers the chance to share that pleasure and revel in the glory of a well-considered solution. Yet even the most playful mass-produced objects retain a slightly chilly air. They may have funky profiles, but their surfaces are usually smooth and undeveloped; they may be brilliantly colored, but their hues are unmodulated; and even if they cost dearly, they are replaceable.

Of course, industry thrives on predictability and exact repetition. Advertisers and mass-market retailers aim to offer the same product to customers in Parsippany and Phoenix and Fort Wayne, no surprises. Fine. I'm not a Luddite. I'm very happy with an undistinguished garden hose, trash cans like the Jones's, and black-box audio equipment. I'm seriously delighted that I can replace my rusty muffler or busted alarm clock with an identical one, factory-direct. But while these things make a big contribution to my happiness, I can't say I treasure them. Why not? I think it has a lot to do with how easily they can be replaced. Being human, we read (maybe too much) into things; we can't help it. Our whole beings are geared toward anthropomorphic identification with stuff, identifying bodily, sub-rationally, with chairs and computers and garden hoses. And one of the things we read in mass-produced objects, no matter how gorgeous, is an insistent reminder of our place in the economy: we are replaceable too.

Another reason I don't treasure mass-produced objects is that they don't have much perspective, and they don't have much range. As role models, they're pretty limited. Industrial products and mass-market fashions show us how to be smooth and uniform, efficient and witty, muted, cool and well modulated. That's not much of a point of view. Given a choice, I'd rather live with things that provoke me and make me rethink my assumptions: rowdy, swaggering, take-no-bull tea towels, giddy medicine cabinets, or strong, silent beds. And I'd want them to have warts, and hooked noses, and cowlicks — the kind of twitches and bumps and peculiar materialities that don't come out of a mold. Not because I love warts, but because texture and irregularity are so fundamental

to our physical selves. We aren't naturally uniform, and our lives are full of contradictions and complexity. So why do so many of the things we buy tell us otherwise? A steady diet of precise, assembly-line sameness is unnatural, and I want — no, need — to be solidly grounded on the earth. I'm a carbon-based life form, and I need things that remind me where I'm from. I'm not ready for life in space just yet.

For all we've learned about genetic coding and the orderly patterns of nature, the more it seems that chaos and mutation are the way our planet and our bodies do business. And this is the way craftspeople work: even their bread-and-butter production items are subject to departures and aberrations. These variations may be slight, even imperceptible, but hand processes leave room for them. This is what distinguishes the work of a maker from that of a designer: trusting the process, rather than imposing an artificial uniformity, and engaging in an ongoing dialogue with materials and techniques, instead of engineering rules to force the variables into submission. Rather than assuming control, the craftsperson opens a channel of communication with the material and prepares to have a conversation.

The sparks generated by that conversation are possibility, discovery, something unforeseen. The resulting objects are the product of an individual testing his or her abilities and renewing the act of creation. I want to

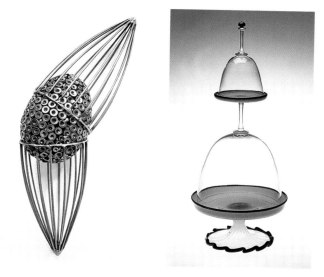

LEFT: WENDY ROSS, *Split Pod.* The process of making generates sparks: possibility, discovery, something unforeseen.

RIGHT: KATHERINE GRAY, *Double-Lidded Cake Stand.* Rather than assuming control, the craftsperson opens a channel of communication with the materials and prepares to have a conversation.

support that effort. I want to know that even if I can't always be knee-deep in primal energy, there are plenty of others grappling with it in their daily work. Living with the objects they make reminds me who I am, what I value, and what I might become.

Jody Clowes is former curator of decorative arts at the Milwaukee Museum of Art, and was previously director of exhibitions at Pewabic Pottery in Detroit from 1989-93. She writes about decorative and architectural arts for publications such as *American Craft, Surface Design Journal, Fiberarts* and *New Art Examiner.*

Tales, 78"ʜ × 59"ᴡ. Art quilt of cotton, silk, wool, linen and metallic leaf. Fabric is discharged, dyed and painted by hand. Photo by Joe Ofria.

Circle Play, 63"H × 63"W. Art quilt made from machine-pieced and quilted cotton scraps. Photo by Allen Fine.

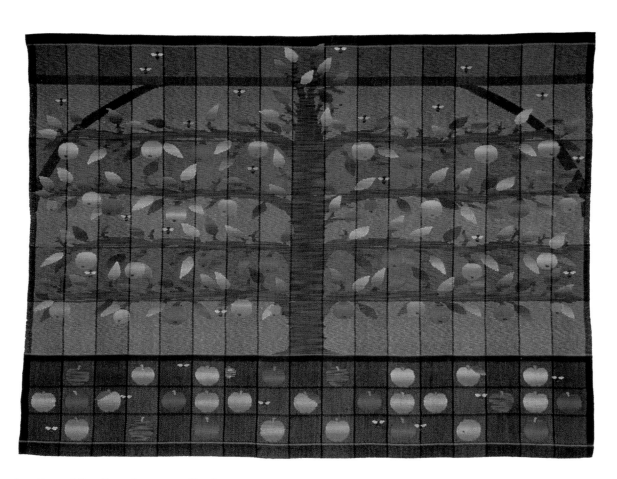

Iron Framed Espalier, 37"H × 47"W. Handwoven tapestry.

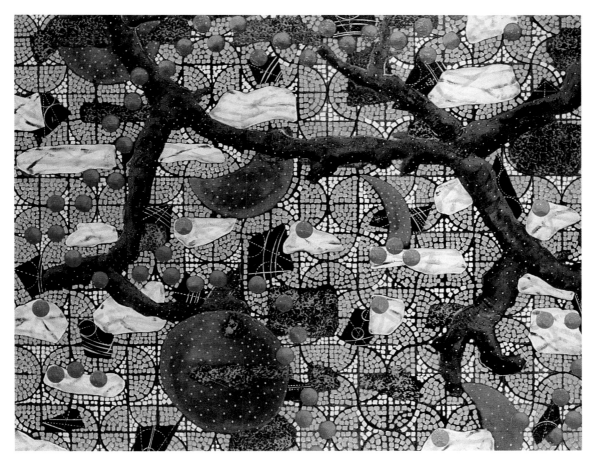

Residence on Earth, 48"H × 60"W. Oil and silkscreen on canvas.

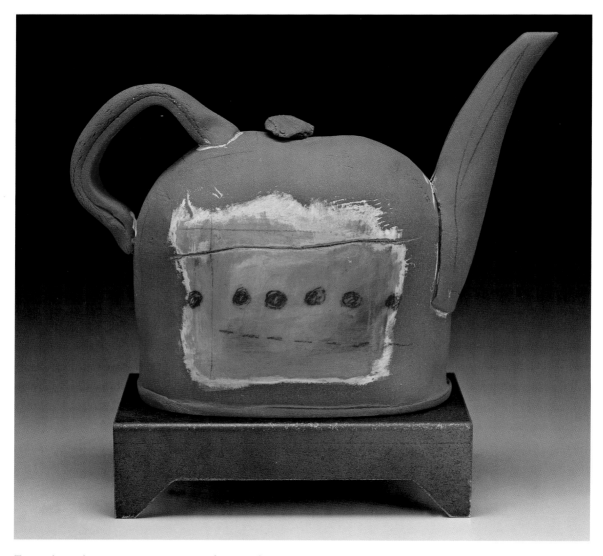

Teapot (#9805), 9"H × 10"W × 4"D. Non-functional terra cotta teapot with underglaze colors and steel trivet.

Wayside Shrine, 50"H × 30"W. A reductive woodcut on Suzuki rice paper. Courtesy of Tandem Press.

Image Stone: Moon Side, 18.75"H × 15"W. Photolithograph, aquatint and gravure. Courtesy of Segura Publishing Company, Inc.

Homage to N.S., 34"H × 43.5"W. Lithograph with silkscreen and etching. Courtesy of Landfall Press, Inc.

Asleep, 30"ʜ × 24"ᴡ. Oil on photograph on panel.

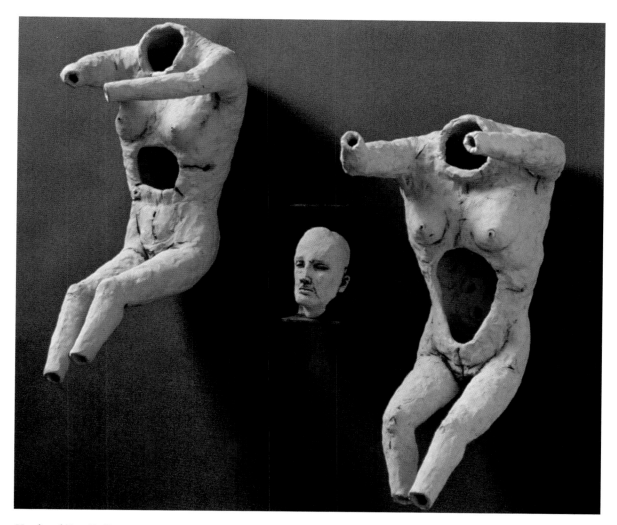

Head and Two Bodies, 24"ʜ × 25"ᴡ × 11"ᴅ. Wall-mounted sculpture made of ceramic and mounting steel.
Courtesy of John Elder Gallery. Photo by Cathy Carver.

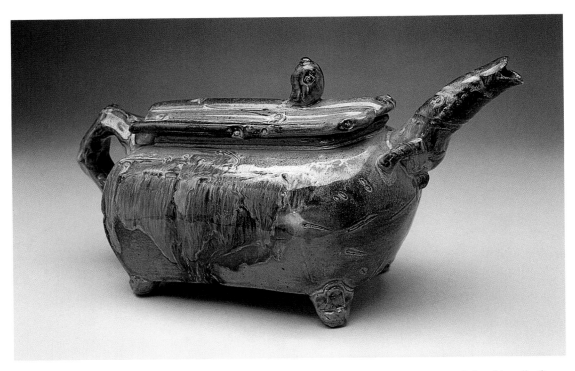

JOHN P. GLICK, *Sculptural Teapot*, 7.5"H × 12"W × 5"D. Sculptural stoneware teapot, extruded and handbuilt. Photo by John Glick.

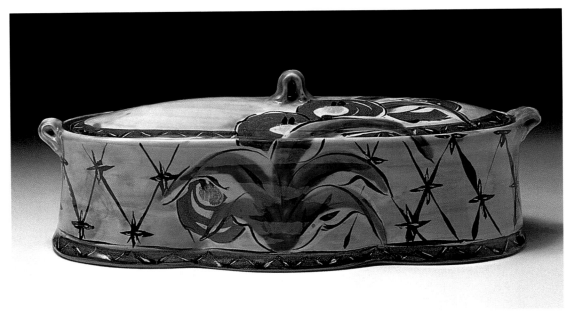

POSEY BACOPOLOUS, *Covered Oval Casserole*, 4"H × 12"W × 5"D. Wheel-thrown terra cotta casserole with a majolica-glazed finish. Photo by D. James Dee.

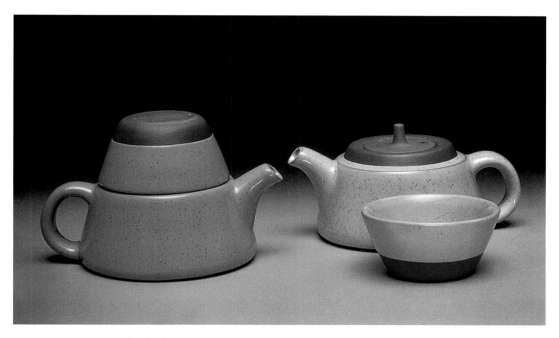

PAUL ESHELMAN, *Individual Teapot*, 4.5"H (each). Teapot and tea bowl made from slip-cast red stoneware.
Photo by Peter Lee.

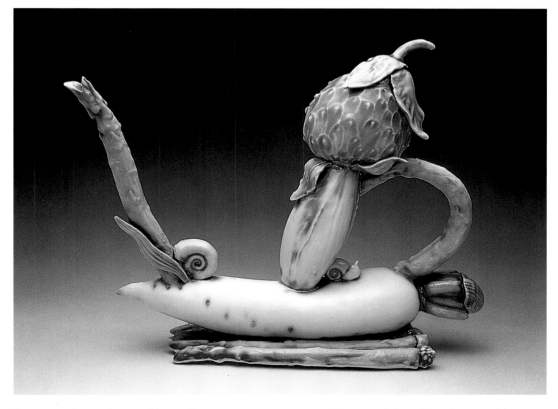

EUNJUNG PARK, *Journey Along a Stream*, 10"H × 12"W × 4.5"D. Cast porcelain sculptural teapot with a
matte glaze finish. Courtesy of Ferrin Gallery.

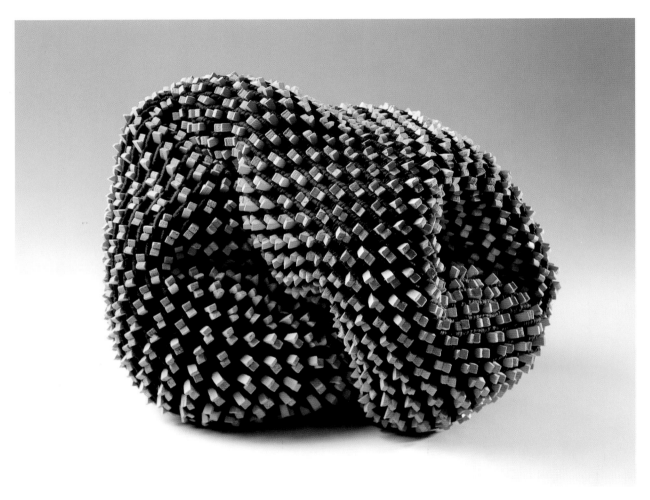

Pelvic Tilt, 12"H × 15"W × 10"D. Sculptural vessel made from cotton twill tape, thread and miniature wood clothespins.

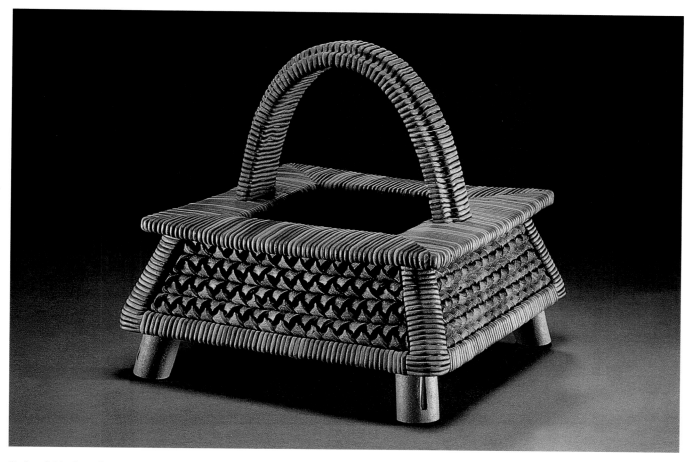

Red and Black Basket, 12"H × 12"W × 12"D. Handbuilt woven red and black clay basket.

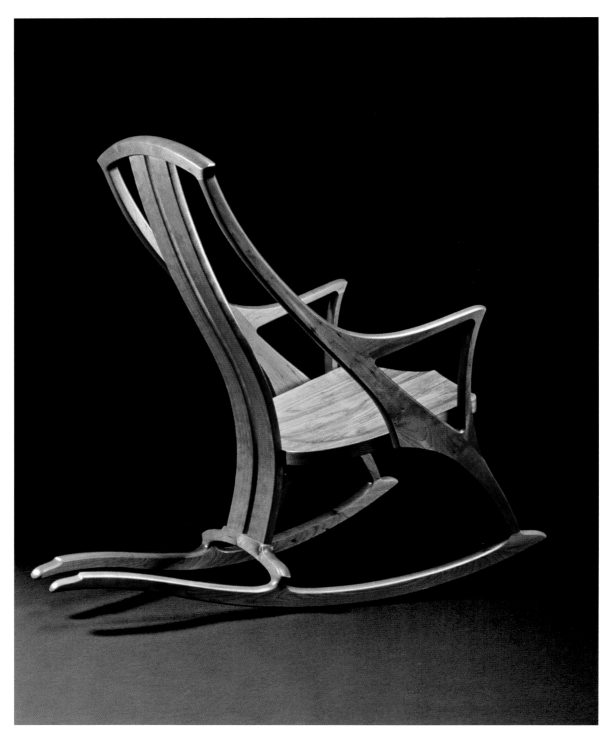

Rocker, 42"ʜ × 24"ᴡ × 44"ᴅ. Cherry wood rocking chair.

Chest, 18"H × 29"W × 17"D. Chest made with woven red elm or ash and cherry wood accents. Photo by Wayne Torborg.

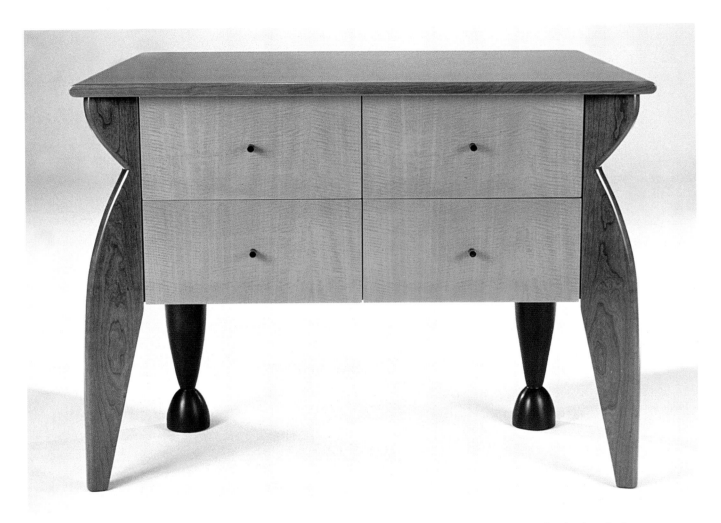

Alexander Chest, 31"H × 40"W × 20"D. Chest made with cherry veneers and solids, stained anigre veneer and stained poplar legs.

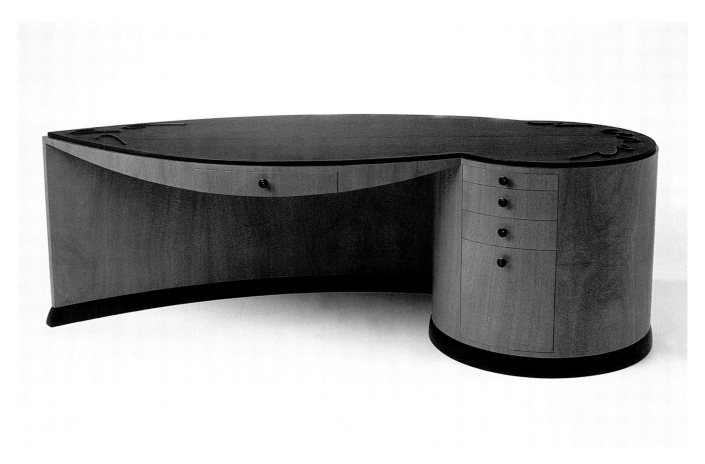

Point of View, 30"H × 86"W × 36"D. Figured and natural mahogany desk trimmed in ebony and leather.

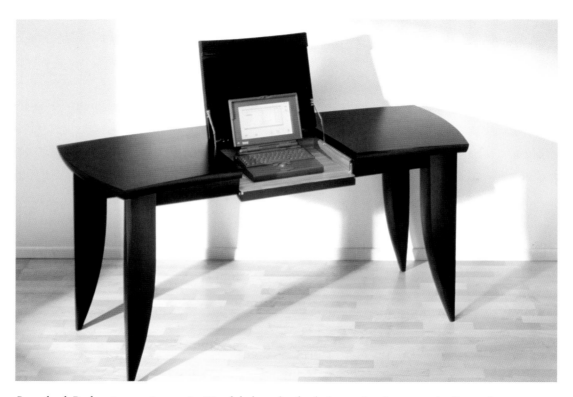

Powerbook Desk, 30"H × 32"W × 32"D. Wood desk made of polychromed mahogany and tulipwood veneer.

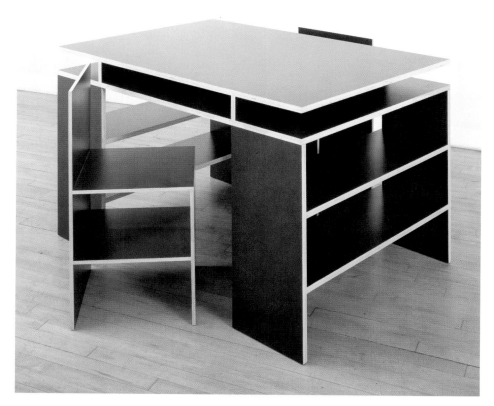

Desk Set, desk (30"H × 33"W × 48"D), chair (30"H × 15"W × 15"D). Desk and two chairs made from birch plywood, mahogany plywood, hardwood or common pine. Courtesy of A/D.

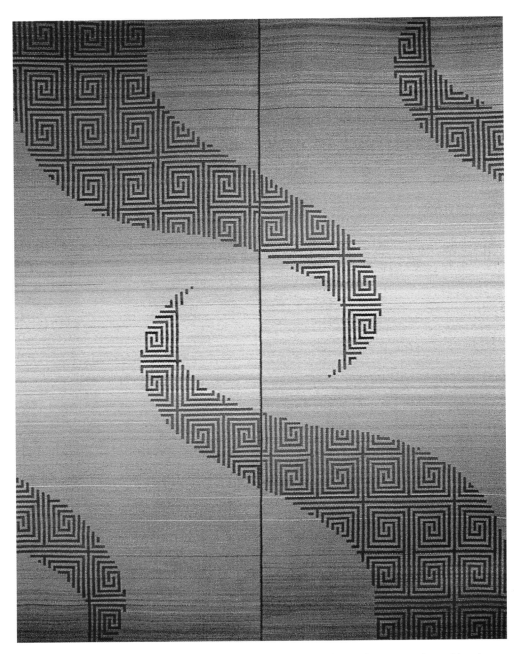

Vortex, 128"H × 96"W. Reversible floor rug woven of worsted wool spun from Argentinean Lincoln fleece and dyed by hand. Warp is Belgian linen. Photo by John Birchard.

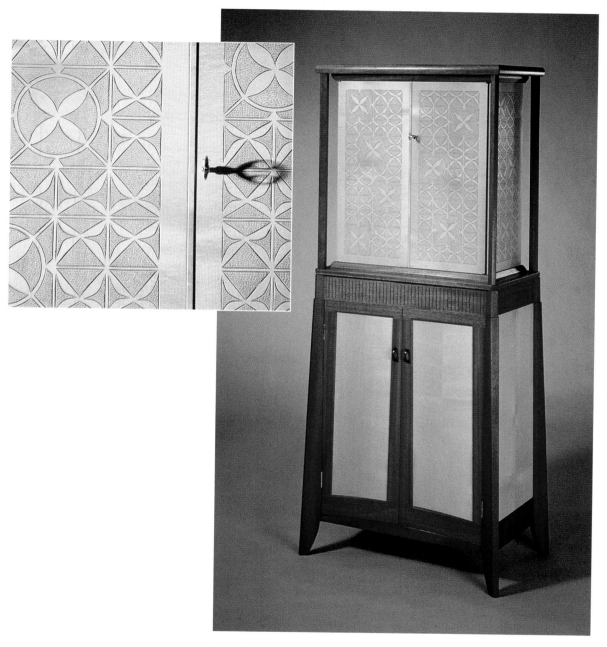

Carved Cabinet, 63"H × 27"W × 17"D. Two-tiered cabinet made of English sycamore and mahogany. Photo by Shooting Star Photography.

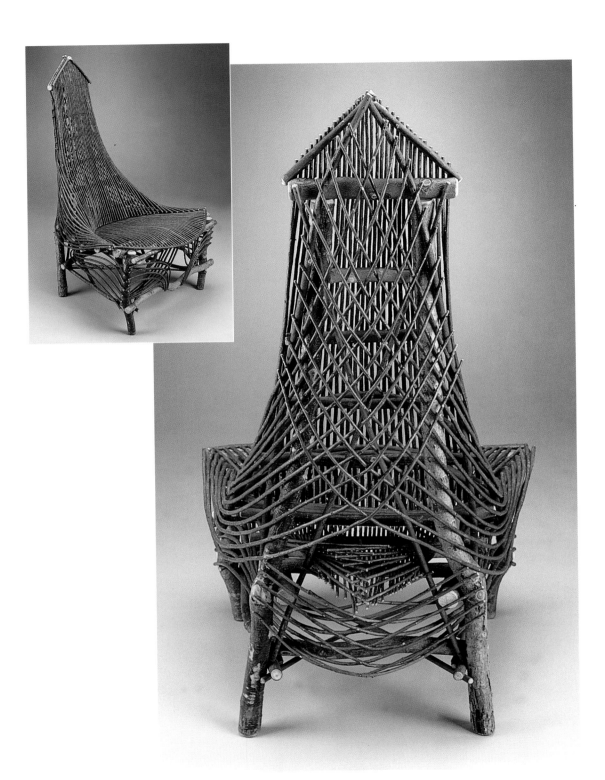

Untitled, 48"ʜ × 29"ᴡ × 32"ᴅ. Functional chair made with a sturdy aspen frame and willow twigs that wrap around the back.

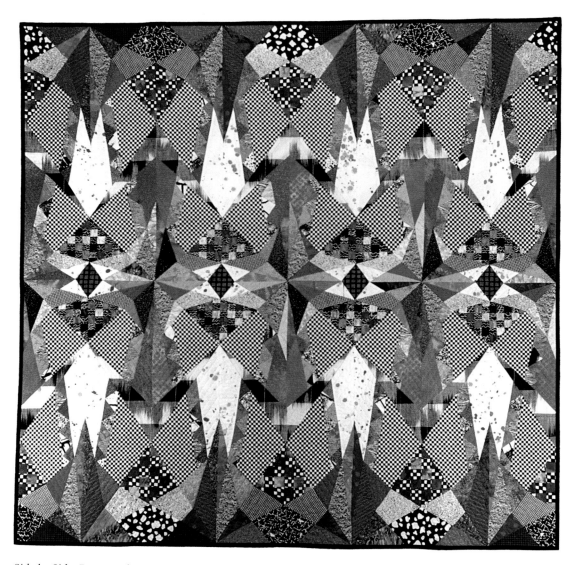

Side by Side, Down and Up, 49"H × 49"W. Art quilt. Machine pieced and quilted, with some fabrics silkscreened by the artist. Photo by Sharon Heidingsfelder.

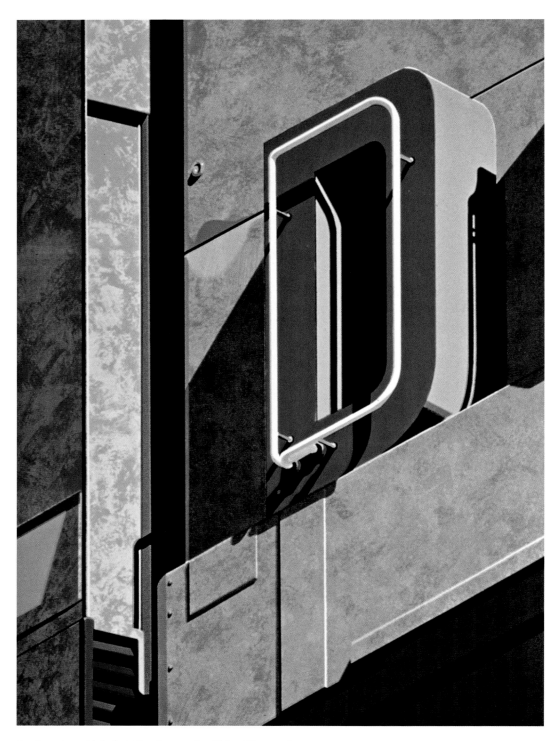

An American Alphabet: D, 31"H × 23"W. Color lithograph on paper. Courtesy of Tandem Press.
Photo by Greg Anderson/Jim Wildeman.

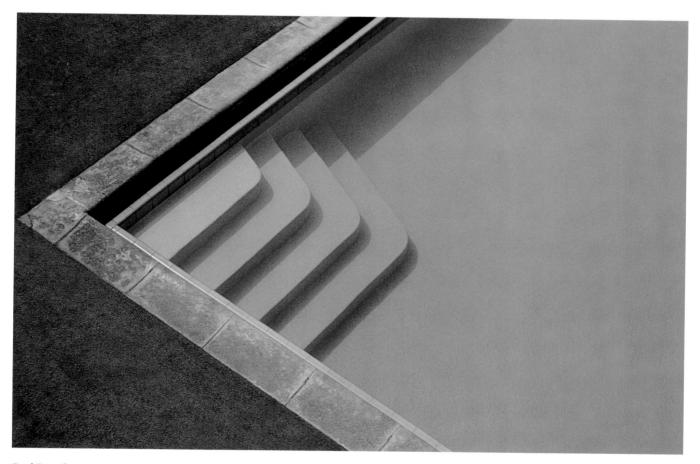

Pool Detail, 8"H × 10"W. Digital print on watercolor paper.

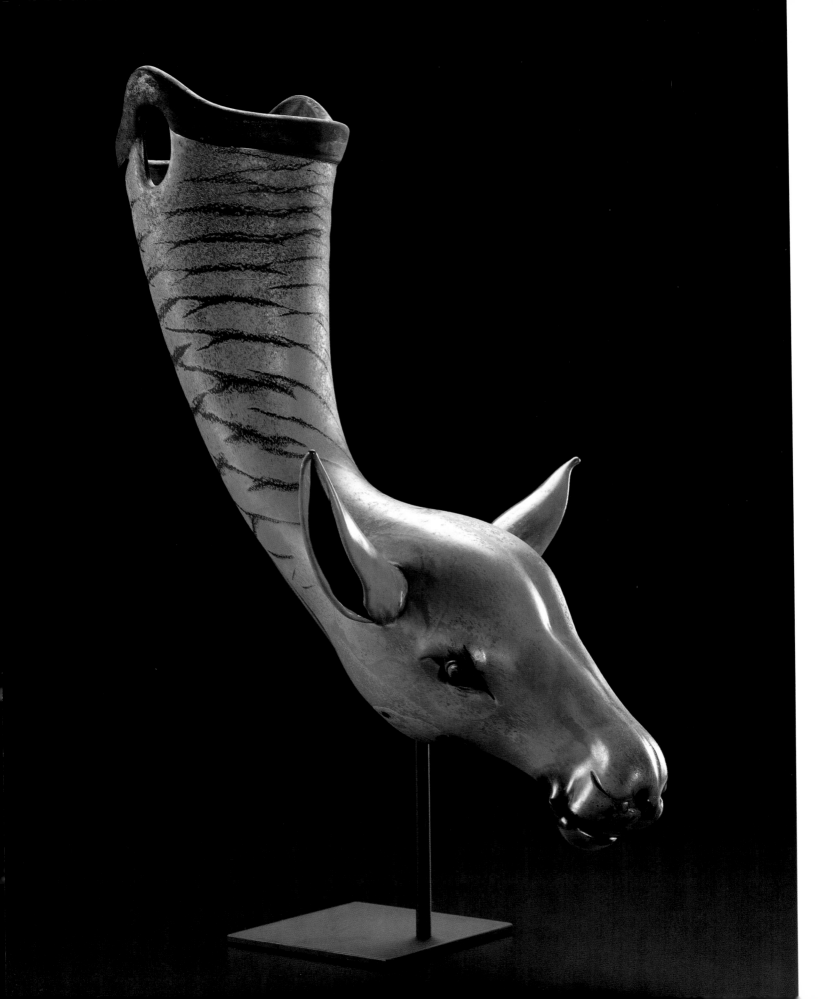

THE SHAPE OF SHADOWS

ESSAY AND COLLECTION BY LLOYD E. HERMAN

A friend phoned me yesterday with an unusual question. She had acquired a child's Ku Klux Klan garment and hood and wondered if I thought a museum might want them. Her query reminded me of one of my first lessons as a new employee of the Smithsonian Institution in the 1960s.

My boss, Frank A. Taylor, was a revered museum professional, and he taught me that a single object can tell many stories. Just as that simple, unadorned white cotton dress recalls bigotry, burning crosses and lynch mobs, so does it also tell us of childhood and its wonders, cotton growing in the American South, education and family life. Who made that dress? Who wore it? Their lives are part of the story, too.

Ever since early cave dwellers drew stick figures on cave walls to describe the hunt (p. 86), art has been a medium for storytelling without words. Though text sometimes appears with imagery, in the visual arts we usually intuit meaning through representation of a real or imagined world. Artists today have no boundaries to the expressive ends they pursue through narrative images.

Since the earliest art — cave paintings — pictures have told stories. In the Middle Ages, church windows celebrated Bible stories in a way that both literate and illiterate could appreciate. No one need second-guess the identity of a baby lying in a manger surrounded by farm animals and people. Such a tableau can speak volumes. Similarly, a recognizable image such as Leonardo's painting of Christ's last supper can inspire other art. Judy Chicago's famous narrative art installation, *The Dinner Party,* used the device of a table set for a party to depict women throughout history.

The image of a single object, be it a wedding cake or the tattered American flag that inspired the writing of our national anthem, can also evoke an entire story. The silver trowel made to serve such a cake, such as that made by Mardi-jo Cohen (p. 110), immediately identifies its ceremonial use. Who does not recall the Prince's search for Cinderella when seeing Silvia Levenson's glass slipper resting on a velvet cushion (p. 111)? Though these particular iconic objects speak to us, in other cultures there are undoubtedly other symbolic objects or scenes that are silent reminders of a full story. To a Western tourist in an Arabic country, for example, a worked metal Hand of Fatima might be only an interesting bauble with no

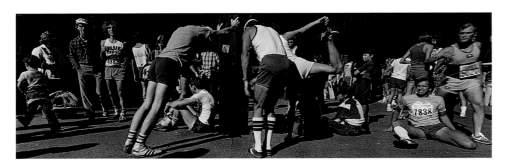

DAVID AVISON, *Runners Stretching before the Chicago Marathon, Chicago.* Contemporary political figures and news photos are inspiring imagery for many artists who use narrative.

potent spiritual significance, but to Muslims each finger has meaning. The thumb represents the prophet Mohammed, and the four fingers his daughter, Fatima; her husband, Ali; and their two sons.

Like medieval stained glass windows, tapestries speak to us from the past with scenes of victorious battle, mythology and pageantry. Such portable murals once warmed dank castle chambers, but their early-20th century counterpart — the history mural — brought to post offices and other public buildings such homely reflections of America as the bountiful harvest, the fruits of labor in industry, and the wagon trains that settled the West. With the advent of motion pictures and television, a new source of visual imagery for artists emerged — the nightly news. Where images of our founding fathers or national heroes once decorated classrooms, celebrity faces dominate our news media today. Pictures of all remind us of their exploits or attributes. Even cartoons — whose sequential scenes are an important method of storytelling — provide characters whose personalities and attitudes are well known. All of these examples of popular story-telling art persist today in autonomous objects that one can buy to hang in the home and in murals and tapestries that can be commissioned for specific places.

Not all of us want to live with art that tells specific, easily recognizable stories, preferring more open-ended

images of people, still lifes or landscapes. Portraits too can suggest tales, as can landscape scenes and pictures of floral bouquets, but they do so in a fragmentary way that raises more questions than answers. What is the person wearing in that picture? Does clothing indicate social status, or a special occasion? Is that a slight smile, or a scowl? Are the flowers in an elaborate bouquet placed on a polished tabletop, or wild flowers hastily plunged into a jar filled with water? Even a painted vista might evoke nostalgia for a childhood vacation, visually conjure a place of romance, or help recall historic events. Similarly, a pattern of roots can envelop a vessel (p. 88), just as a bowl decorated with feather images recalls bird flight in more generalized terms. Such abstractions can also create moods — they may calm or inflame, recall or reflect. We have become accustomed to abstracted images in art and read them

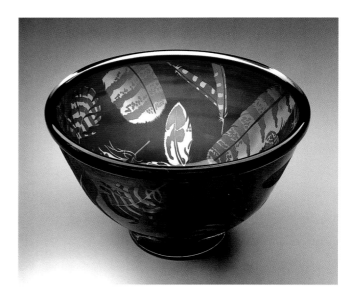

MARY MULLANEY, *Feather.* Artists often use open-ended images to suggest tales in a fragmentary way. This bowl by Mary Mullaney recalls bird flight, but it does so in generalized terms.

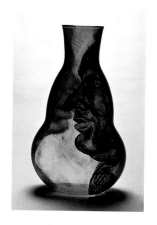 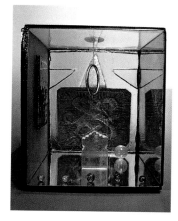

LEFT: DICK WEISS, *Melissa and Chris Just...* Dick Weiss gives us only an intriguing title and two profiles in this glass vase, leaving us to fill in the rest. Photo by Roger Schreiber.

RIGHT: DANA ZED, *Many Moons.* Zed's intimate glass box captures the essence of Joseph Cornell's highly personal narratives.

just as quickly as a flicker in a motion picture montage.

Abstracted images may simply be distortions of reality, such as the elongated human faces in paintings of Modigliani. We can perceive familiar forms in the shape of shadows, or clouds, and imbue them with meaning. Surrealism presented us with enigmatic scenes that encouraged this kind of imaginative seeing by combining the known reality of our lives with unexplained elements — such as Dali's melting watches — that make no rational sense to our consciousness. The mid-century assemblage artist, Joseph Cornell, combined disparate elements to suggest narrative in what one critic called "boxed poetry." The mysterious quiet of his surrealistic works seems to be quoted by Dana Zed in *Many Moons* (above).

Whether objects are made purely for contemplation or with a real or implied function, they may succeed in our eyes and our intellect as art objects. The definition of

"art" has never been so subjective. Many of us continue to find beauty in images of the recognizable, be they flat images to hang on the wall; ceramic and glass vessels or sculpture, jewelry and furniture that combine functionality with storytelling power; or art quilts or tapestries. Our lives are enriched by all of these art forms, and the stories they can tell.

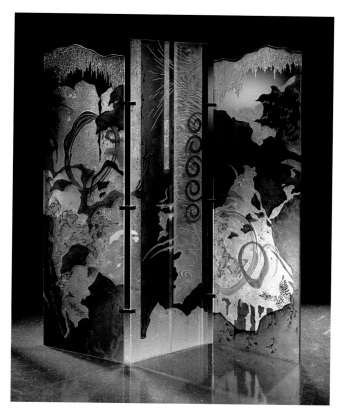

MARKIAN OLYNYK, *Winter Series.* This glass screen by Markian Olynyk captures the magic of finding images hidden in the clouds. Photo by Fotografica Studio.

Lloyd E. Herman is one of the foremost authorities on the contemporary crafts movement in the United States. From 1971 until 1986, he served as founding director of the Smithsonian Institution's Renwick Gallery in Washington, D.C. He is currently acting senior curator of the International Glass Museum in Tacoma, WA.

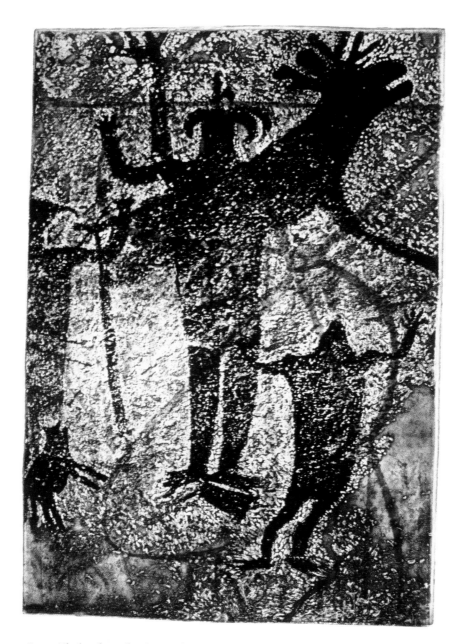

Cueva Flechas from the *Cave* series, 2000, 18"H × 12"W. Photoetching on paper.

Divided Memory, 1992, 59"H × 115"W × 2"D. Fiber wall piece construction with painted and dyed fabrics. Photo by Kurt Wilson.

Divided Memory, detail.

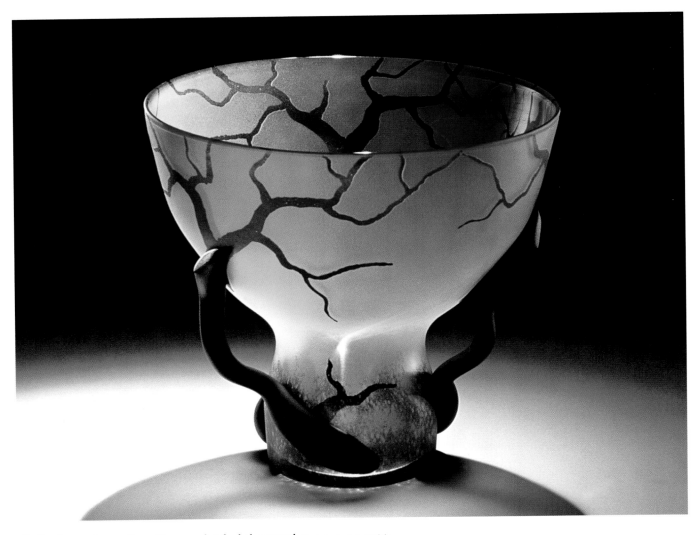

Chalice Root, 11"H × 11"DIA. Blown and etched glass vessel. Photo by Jack Ramsdale.

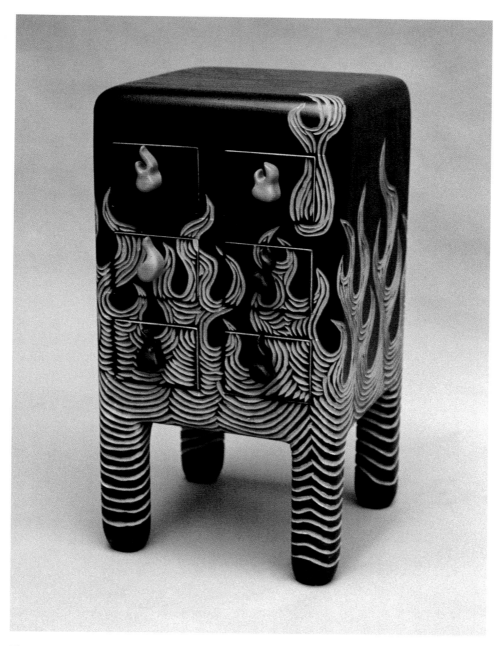

Fire Drawn, 15"H × 7"W × 7"D. Basswood cabinet with six drawers and carved and painted surface design.

Search Me, 1997, 58"H × 44"w. Oil and acrylic on canvas.

His Father's Sky, 84"H × 62"W. Oil on canvas.

M.L. MOSEMAN

Conference, 1999, 24"H × 36"W. Pastel on museum board. Photo by E. Smith.

Newaygo, 1999, 24"H × 24"W. Oil on canvas.

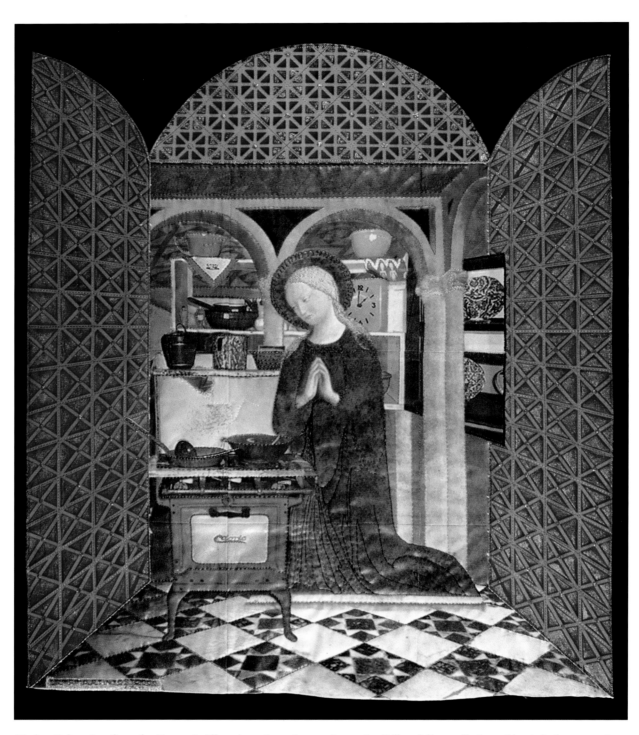

Kitchen Relevation, from the *Domestic Allegories* series, 37"ʜ × 22"ᴡ × 2"ᴅ. Collaged fiber wall piece with stitched construction and heat-transferred images in a wood box frame. Photo by Noho Gallery.

Hand, from the *Cabinet Portraits* series, 1997, 14"H × 11"W. Archival split-toned silver gelatin print.

Figures on a Blue Bench, 70"H × 72"W. Oil on canvas. Photo by Paul Rahilly.

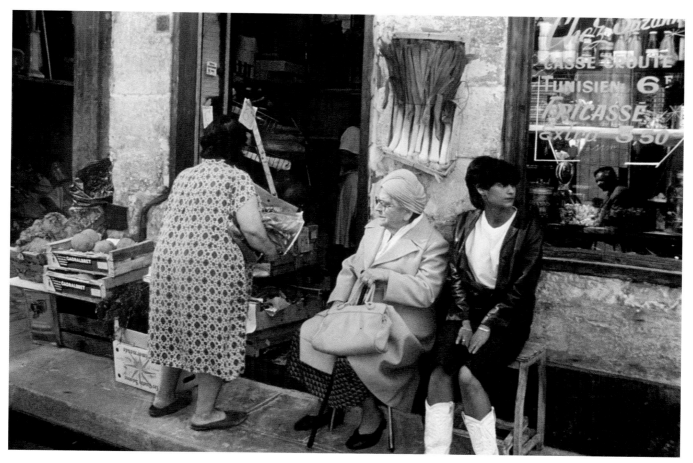

Les Girls, 16"H × 20"w. Handcolored photograph.

Felipe, 1999, 20"H × 16"W. Archival digital print on handmade watercolor paper. Printed in collaboration with Cream City Editions.

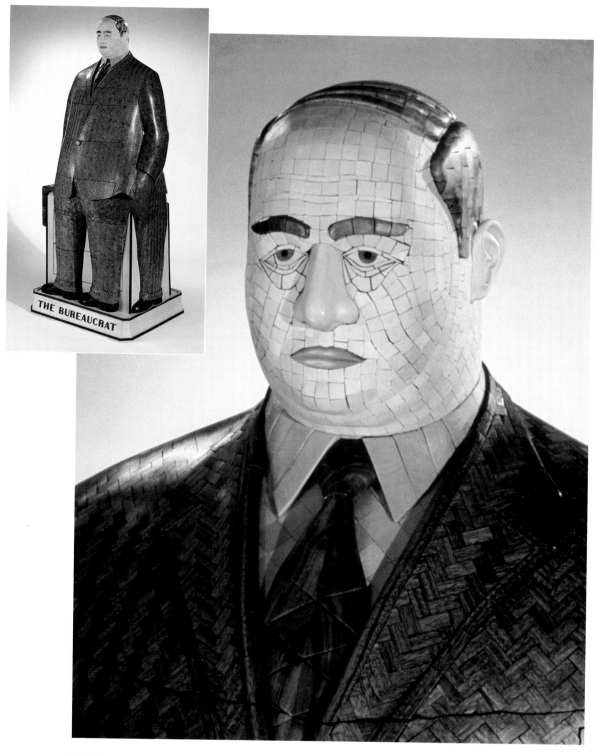

The Bureaucrat, 68"H × 22"W × 18"D. Wood sculpture that is also a functional bureau with six drawers made from verawood, holly, walnut, ebony and maple.

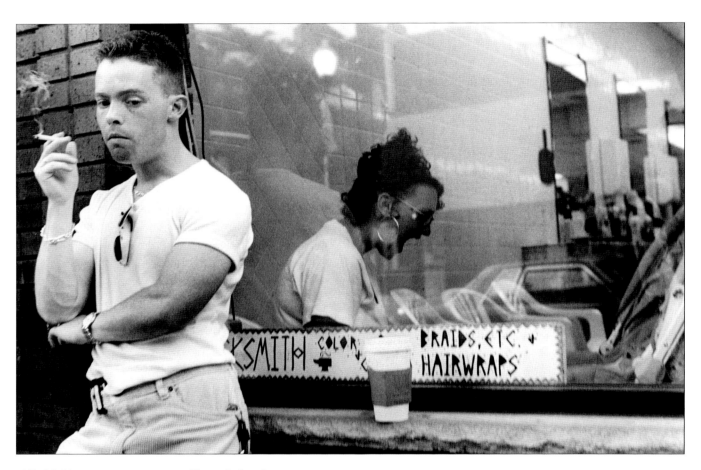

Philadelphia, PA, #2, 16"ʜ × 20"ᴡ. Silver gelatin print.

Mother and Child, 2.75"ʜ × 4.25"ᴡ. Silver gelatin print.

Bazaar, 1999, 14"ʜ × 20"ᴡ. Iris print on archival watercolor paper.

Café 1, 13"H × 10"w. Handcolored silver gelatin print on fiber-based paper. Selenium-toned and colored with photographic oils and oil pencil.

El Remedio, 1998, 72"h × 96"w. Oil on canvas.

Holy Wars, 19"H × 26"W. Iris print on 100% cotton rag paper. Photo by Forrest Doud.

Wintercreek, 39.5"H × 63"W. Art quilt. Cotton fabric painted with dye and pigment and quilted. Photo by Karen Perrine.

Landscape Vase — Large, 10"H × 5"DIA. Blown glass vase with applied surface decoration.

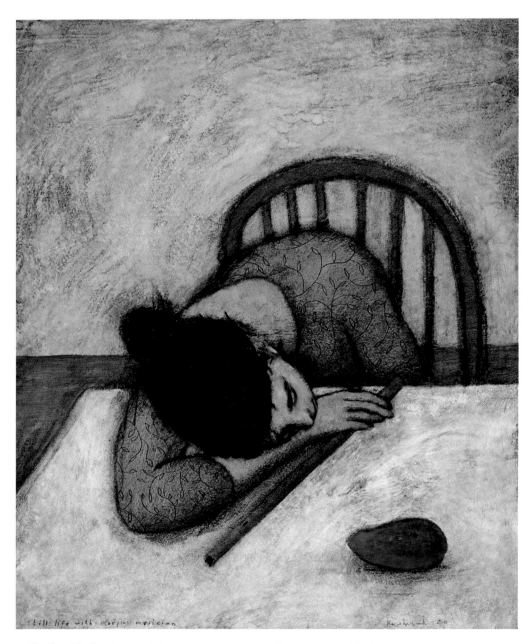

Still Life with Sleeping Musician, 24.5"ʜ × 20" ᴡ. Giclée print on archival paper.

Five Citizens: LaMar, 36"H × 37"W. Hand-knotted wool and silk wall piece portraying art historian LaMar Harrington.

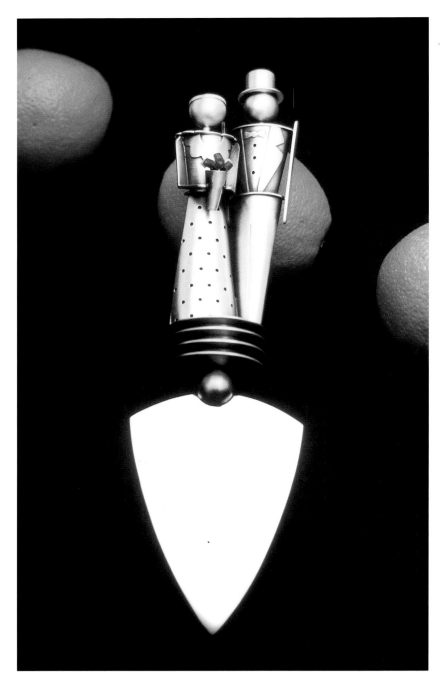

Bride and Groom Cake Server, 10.50"H × 0.75"W. Sterling silver and acrylic cake server.

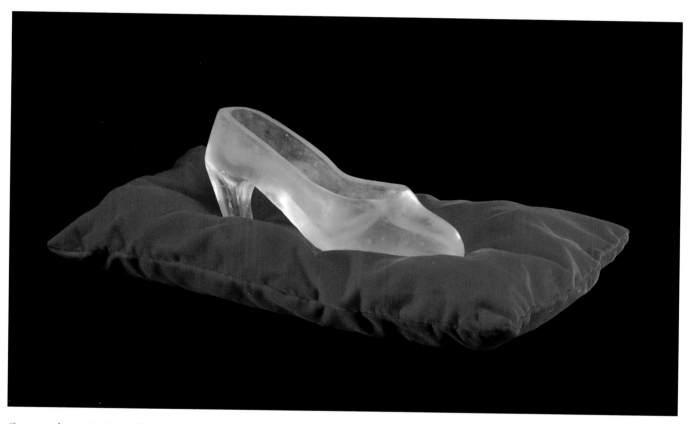

Cenerentola, 1998, 4"H × 3"W × 9"D. Pâte de verre glass sculpture. Courtesy of the Bullseye Connection. Photo by Paul Foster.

CULTURAL CANDY

ESSAY AND COLLECTION BY MARTHA DREXLER LYNN

Riffing on past cultures is a common artistic strategy. Echoes of previous periods are, after all, implicit in virtually every object, and every epoch adds its own updated aesthetic and cultural messages. These bits of "cultural candy" enliven and add meaning to artworks by melding traditional forms with contemporary viewpoints.

Although objects made during the era of high modernism reflect an active rejection of historical links, today's makers rely heavily on a knowledge of the history of their media for their inspiration. As Kenneth R. Trapp, Curator-in-Charge of the Renwick Gallery, Washington, DC, has noted, craft "always makes reference to *traditions*."[1] These underlying traditions are derived from a variety of cultures and epochs, previous stylistic modes and historic media and processes. All of these strategies provide an implicit comparison between the original expression and the new iteration. In this way, the past becomes a vivid present.

Stimulus from historical forms is a fertile area for the contemporary artist. Diane Echnoz Almeyda's *Hummingbirds* (p. 125) draws inspiration from medieval liturgical wares and the enamel and stained-glass window technique of plique-á-jour. The tiny bowl is decorated with a hummingbird drinking nectar from a red-and-yellow flower. The vivid turquoise enamel used for the background plays off the multicolored flower and the bird's green and magenta plumage. The metal frets that create

the images add texture and reflect light, enhancing the glasslike glitter of the enamel. Petite in scale and designed to delight both eye and hand, this work is further enriched with a crenellated rim that recalls imperial crowns of old.

Jackie Abrams's *Forest Path Gem* (p. 140), in contrast, seems like a found prehistoric object. Constructed from watercolor papers stitched together and embellished with acrylic paint, it brings to mind cave paintings and naturally occurring formations of rock and stone.

Non-Western cultures are a particularly rich source of traditional inspiration. Objects suggestive of sacred ritual have appeal because of their association with spirituality. In Erik Wolken's *Totem #2* (p. 133), a functional CD cabinet is fashioned in the form of an upright totem symbolizing the godhead. By lightheartedly mismatching form and function, Wolken updates the presentation of music from the context of ritual to that of the compact discs. In this way the "guts" of both the actual piece and its spiritual use are linked. A similar approach is seen in Vivian Wang's Chinese-inspired

[1] Bob Sinclair, "Kenneth R. Trapp: I Start with the Work of Art Itself," *Renwick Quarterly* (summer, 1997), np.

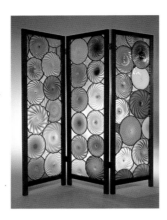

DICK WEISS,
Zirkus. Weiss's multicolored screen showcases the beauty of stained-glass rondelles. In American colonial times these forms constituted the only type of flat glass available for architectural use. Here a charming swirl pattern (the result of being blown and then flattened) adds interest to the segmented form.
Photo by Russell Johnson.

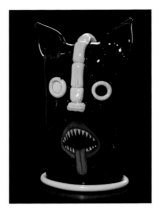

PAUL MARIONI,
Dark Gray Jaguar. Marioni updates the millennium-old notion of the ritual mask. Made of blown glass, the mask graphically depicts an animal face with sharp teeth and yellow-rimmed eyes. The ritual function is stripped away from this object of contemplation, but it nonetheless carries the power of a distant past.
Photo by Robert Schrieber.

Baby Lady (p. 117). Here a physician's doll, customarily used to facilitate medical diagnosis, is transformed into an inviting, chubby child-woman with rounded thighs and a coquettishly turned head. By adding Kewpie doll allure, Wang subverts the modesty of the original into a work that intrigues and charms.

Stylistic conventions from previous eras also provide a starting point for contemporary artists. Bridging both Western and non-Western artistic expression, Cubist sensibilities are a common source of inspiration for contemporary two-dimensional and three-dimensional pieces. Marie Mason constructs her *Music in Detail* (p. 145) with wide, blocklike passages of color surrounded with muted background tones. Her forms are geometrically defined, with intense white and red areas reserved for the rendering of the figure and his violin. In a further piece of visual shorthand, the shadows are edited to read as single planes projecting and receding in space. This use of abstract subsidiary shapes that coalesce into larger forms, and ultimately complete images, is a strategy that was pioneered at the end of the 19th century by the French artist Paul Cézanne and then expanded by Georges Braque and Pablo Picasso. While considered outlandish at the time it was introduced, Cubism has become a time-honored representational convention — one that permits the viewer to appreciate the image on two levels: as a whole and as a pleasing arrangement of abstracted shapes. By presenting her forms as flat shapes and defying the Renaissance rules of three-point perspective, Mason adopts the Cubist sensibility as her own.

Similar spatial distortions and pattern making are seen in *Dreaming of Mali* (p. 129). Here Barbara Butler decorates her three-dimensional pinewood cabinet with bold shapes, which are derived from nature but abstracted into Cubist patterns that seem both primitive and sophisticated. Butler joins African art, prized by the Cubists for its immediacy and rigorous expression, to the American tradition of painted and chip-carved furniture. One even senses a nod toward the early works of American studio furniture pioneer Wharton Esherick. As the making of objects is part of a long continuum that links one artist to the next, many delight in paying homage to trailblazers in their field.

Other contemporary forms also make interesting starting points. Lisa Jacobs's *Whimsy Chaise* (p. 134) neatly updates the reclining daybed, or chaise, from its famous, early-19th-century continental version. The original chaise encouraged one to recline languorously on luxurious satin and mahogany, but Jacob's version is upholstered with a floral cut-velvet fabric on a furniture frame of forged metal; it maintains the overall line of the prototype, but the materials and decoration are cartoonish. Other furniture styles also lend themselves to contemporary reinterpretation. In *Clove Chair and Ottoman,* Jack Larimore (p. 143) takes an over-

stuffed chair and ottoman with traces of Art Deco styling, abstracting the chair into a "clove" supported by animated legs. By presenting the elements of bygone forms in such a lively manner, Jacobs and Larimore help us see them afresh.

Just as items from the distant and near past are inspirational, so are forms seen in popular culture and observed in everyday experience. Indeed, one of the innovations of the second half of the 20th century was the introduction of banal objects as appropriate topics for art-making. Jasper Johns and Claes Oldenburg led the way in painting and sculpture, while Robert Arneson moved the sensibility into clay when he founded the Funk Movement. This interest in the ordinary also intrigued those who designed for production. Ettore Sottsass elevated plastic laminate and faux-wood patterns, disparaged by the early-20th century modernists as derivative, into an appropriate medium for making art furniture. Linda Ross's *White Soap Bottles* (p. 120) similarly reformats the ubiquitous detergent bottle into a five-part sculpture of opaque cast glass. By relieving the bottles of their advertising and product information, she reveals the anthropomorphic beauty of their profiles. The five together become a garniture that is a meditation on the beauty of the everyday.

Turning technical achievement on its head can also be a way to bring historical elements to the fore. Randy Schmidt's *Lizard Licker* (p. 138) is reminiscent of the ceramic wares

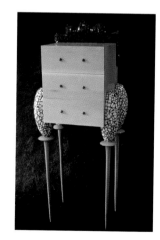

KIM KELZER, *Chicken Cabinet.* Kelzer's finely crafted cabinet riffs on the traditional Sheraton style. In typical late-20th century manner, however, Kelzer updates the form to include a whimsical cockscomb and white porcelain hips (in place of the traditional cabinet's "knees"), placed atop spindly chicken legs.

made by Bernard Palissy. Working in France during the late Renaissance, Palissy was known for his use of wriggling creatures to decorate his works. The tradition of depicting animals in clay has ancient antecedents but reached its height in the Renaissance taste for ceramic grotesques — finely worked earthenware forms encrusted with lizards and snails in grotto settings. Schmidt pairs a man's face with a realistically rendered, wide-eyed green lizard who crawls over his left eye; the man's hands grasp at the lizard's tail and hind leg. This unsettling composition reflects a long historical tradition.

Ginny Ruffner adds a contemporary twist to the Renaissance technique of lampworking in *The Mechanics of Flight* (p. 124). Historical lampwork was used to fashion intricately petite items. Most contemporary lampworking is associated with the circus and carnival where its use in rendering simple forms makes it a perfect spectator activity. Ruffner's work, however, is both intricately made and large in scale. It features gilded feathers and webs that would seem to make flight challenging. By adopting this technically complex medium, Ruffner has produced a work that exceeds its traditional antecedents in depth of content and virtuosity.

Dimitri Michealides, also working in glass, borrows from Art Deco vessel vocabulary to make his *Tall Yellow Wiggle* (p. 126). Fanciful red birds perch on the black handles of the oversized yellow vessel, turning it into an elegant birdbath. Again, a traditional form is enlivened by a modification in scale and a dollop of ironic humor.

Artists tend to have a deep knowledge of the history of their medium. By drawing on this rich history of form and content, contemporary objects link the traditional to our contemporary lives — transforming the past into our cultural candy.

Martha Drexler Lynn, Ph.D., was Curator in Charge of the 20th-century decorative arts collections at the Los Angeles County Museum of Art for ten years.

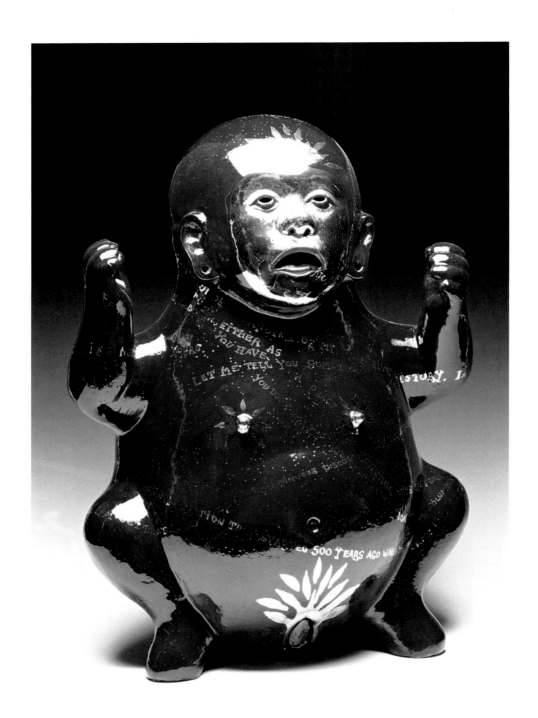

La Neta, 22"H × 11"W × 16"D. Ceramic sculpture with gold luster glaze. Courtesy of Center of the Earth Gallery.

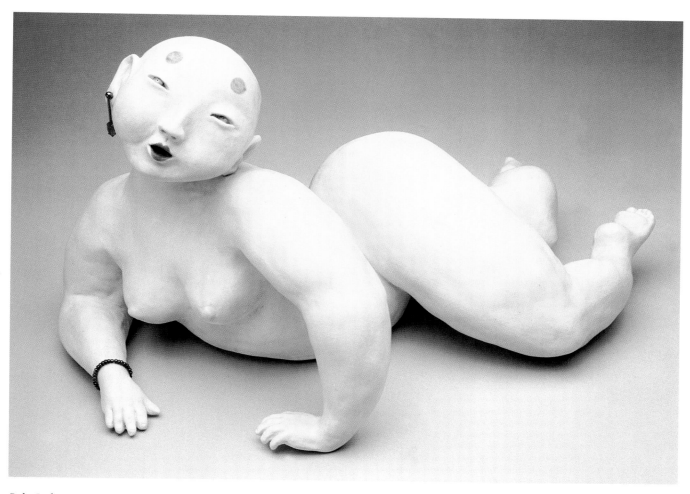

Baby Lady, 8"H × 17.5"W × 9"D. Stoneware sculpture with underglaze and glaze trailing. Finished with a matte crackle glaze. Photo by Kevin Noble.

PHIL CORNELIUS

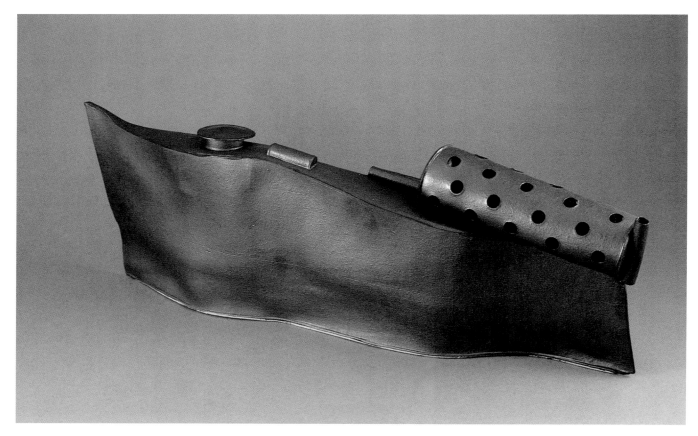

Lakeside, 8"H × 18"W × 3"D. Porcelain sculptural form. Courtesy of Lakeside Gallery.

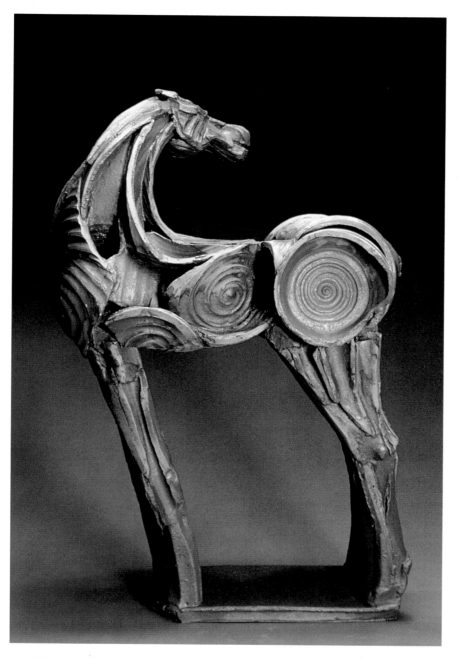

Iron Tribute, Looking Back, 28"H× 22"W × 8"D. Glazed earthenware sculpture made from wheel-thrown and extruded forms.

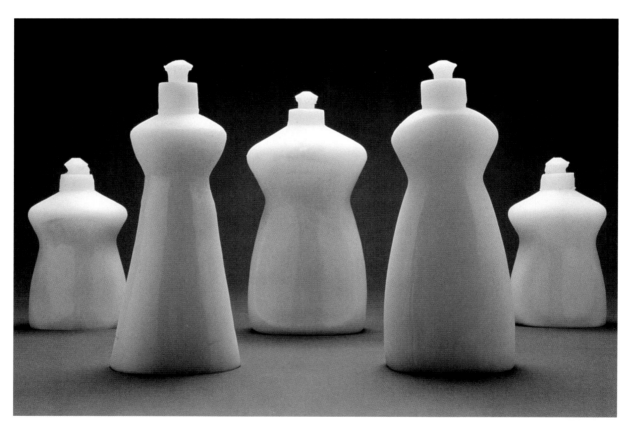

White Soap Bottles, 1999, 12"H × 18"W × 10"D. Five sculptural soap bottles cast in glass that resembles white soap.

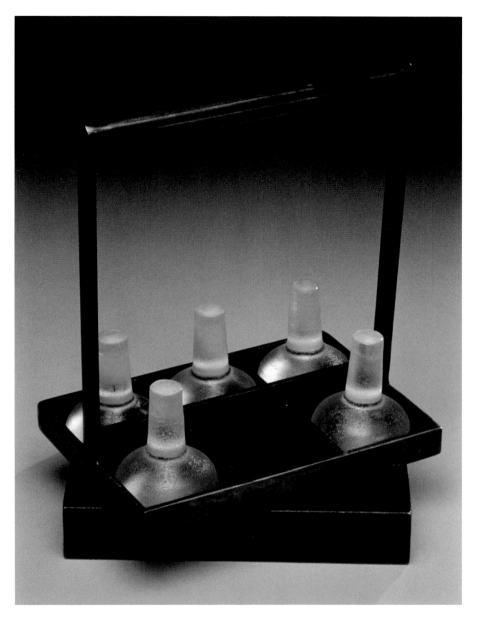

Six Pack, 2000, 16"ʜ × 2"ᴡ × 8.5"ᴅ. Welded metal container and five removable cast glass objects with gold leaf on the underside of each. Courtesy of Center of the Earth Gallery.

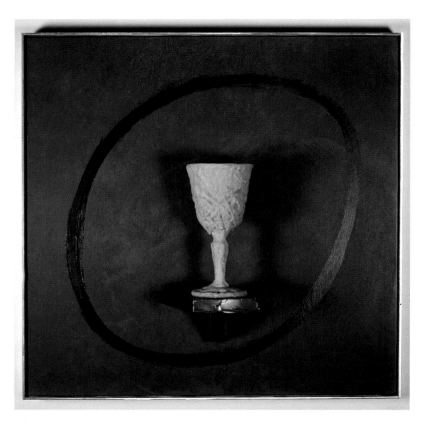

King's Ritual, 24"H × 21"W × 6"D. Wall-mounted sculpture with acid-treated black enamel and a glass vessel encased in beeswax. Photo by Henry Halem.

GAIL McCARTHY

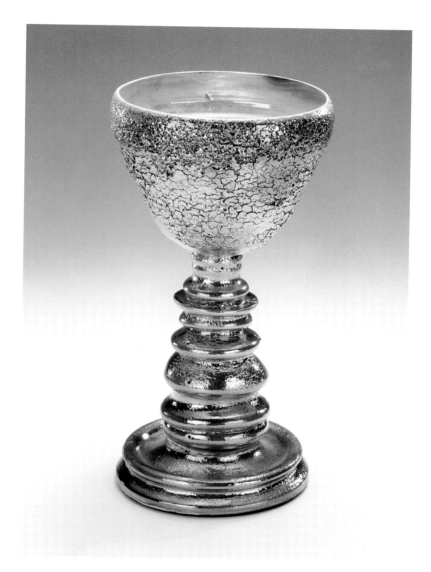

Lustered Vessel #75, 1998, 16"H × 9"W × 9"D. Ceramic vessel with gold, silver, platinum, copper, bismuth and cobalt applied, fired and reapplied. Photo by Photographic Two.

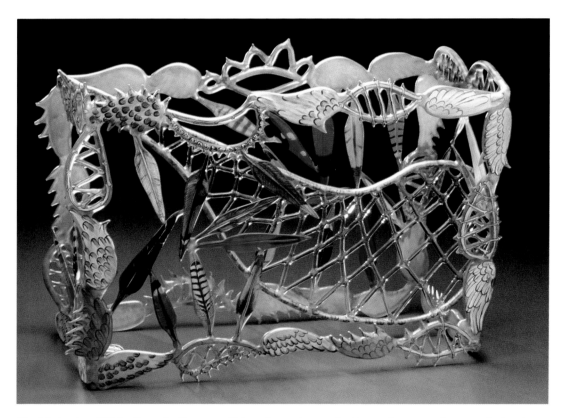

The Mechanics of Flight, from the *Conceptual Narratives* series, 1996, 19"H × 28"W × 9"D. Lampworked and painted narrative glass sculpture. Courtesy of R. Duane Reed Gallery.

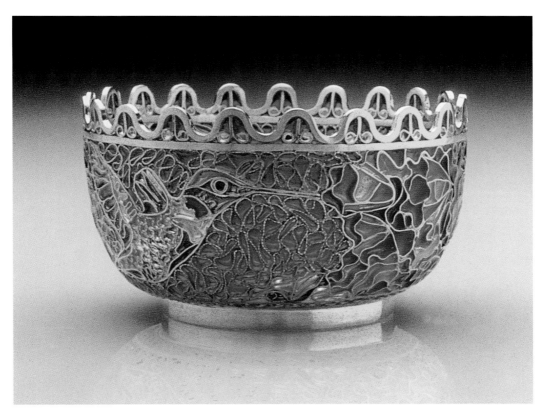

Hummingbirds, 1998, 1.5"H × 2.75"D. Decorative bowl fashioned from fine silver and transparent plique-á-jour enamel with a decorative rim. Photo by Dan Loffler.

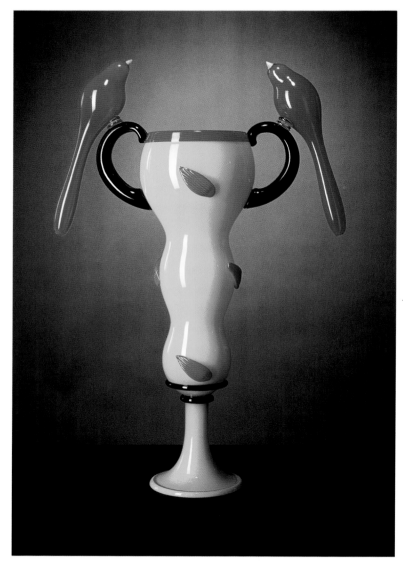

Tall Yellow Wiggle, 23"H × 16"w. Opaque blown glass vessel embellished with individually blown glass birds, handles and flames.

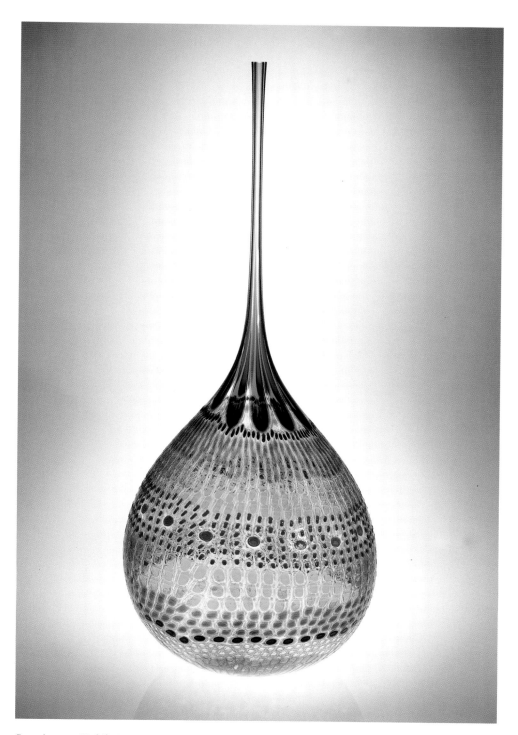

Promiscuous Nubile Jones, 48.5"H × 20"W × 20"D. Large bulb-shaped vessel of blown glass with multicolored murrini surface.

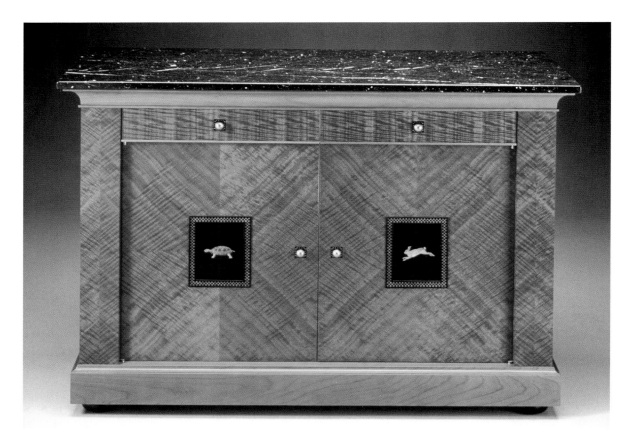

Cabinet with Tortoise & Hare, 38"H × 54"W × 22"D. Cabinet made from cherry with fiddleback makore veneer and negro marquina marble top. Marquetry tortoise and hare panels. Hand-cut dovetail drawers.

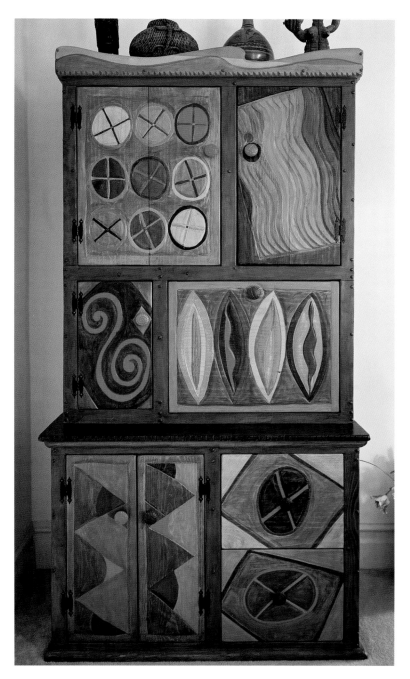

Dreaming of Mali, 80"ʜ × 36"ᴡ × 22"ᴅ. Carved pinewood cabinet with tung oil and commercial pigment finish. Photo by Teena Albert.

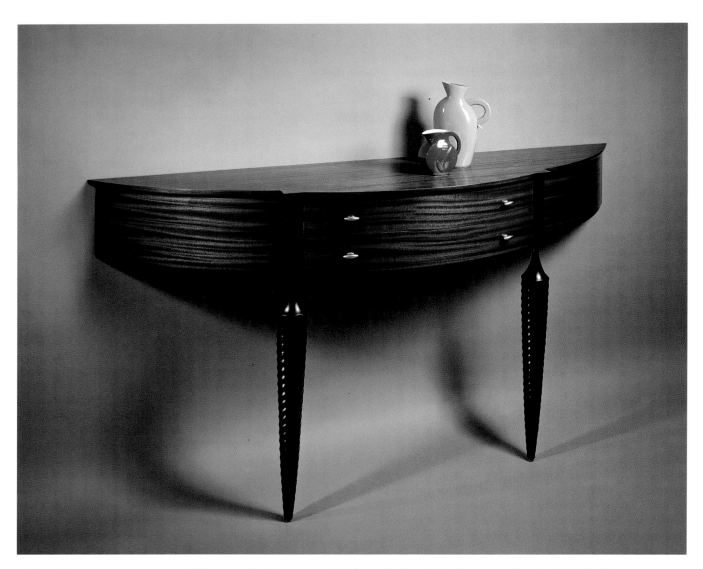

Sideboard, 36"H × 69"W × 17.5"D. Wall-mounted table constructed with sapele, ebonized mahogany and brushed nickel pulls.

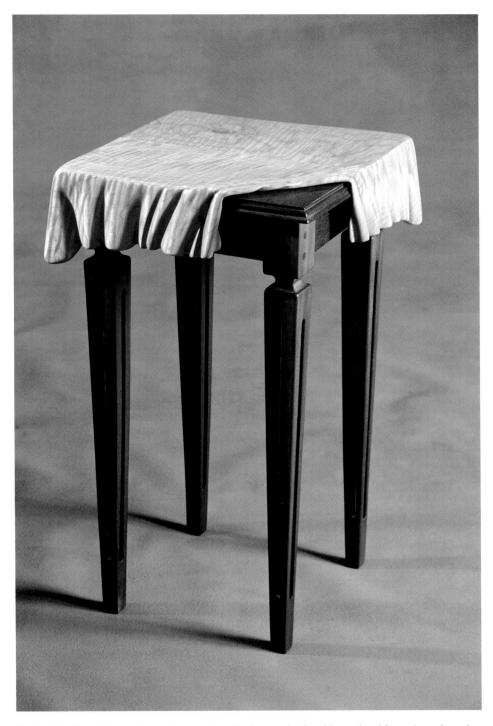

Tablecloth Side Table, 24"H × 14"W × 14"D. Hand-carved side table made of figured maple and mahogany woods. Photo by Sam Sargent.

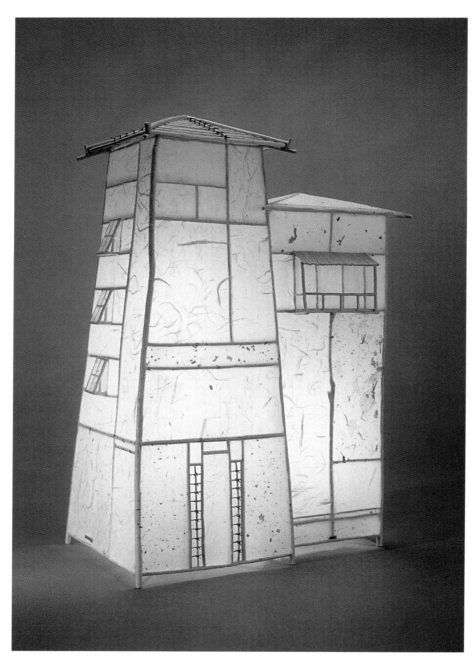

In the Mountain Village, 24"H × 20"W. Illuminated sculpture made of washi, willow and eucalyptus. Photo by Jennifer Cheung.

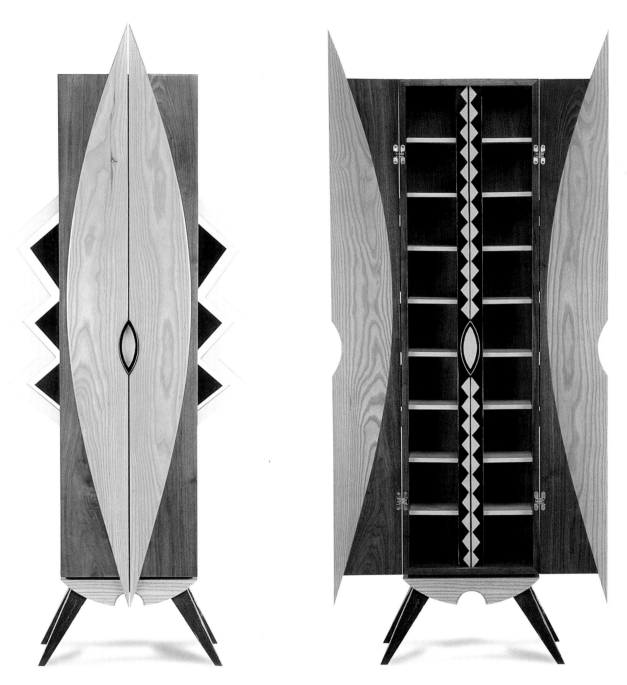

Totem #2, 78"ʜ × 30"ᴡ × 8"ᴅ. Freestanding CD cabinet made with a combination of ash, maple and walnut woods. Photo by Seth Tice-Lewis.

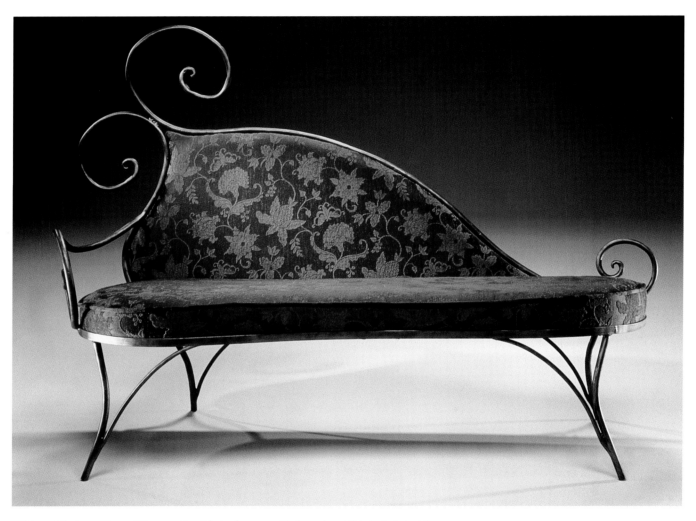

Whimsy Chaise, 46"ʜ × 68"ᴡ × 26"ᴅ. Chaise lounge with forged and fabricated steel frame.

1249 Floor Mirror, 1996, 83.5"H × 38.5"W × 19.5"D. Full-sized mirror constructed from wood and deliberately cut glass, supported by a cast cement base. Photo by David Mohney.

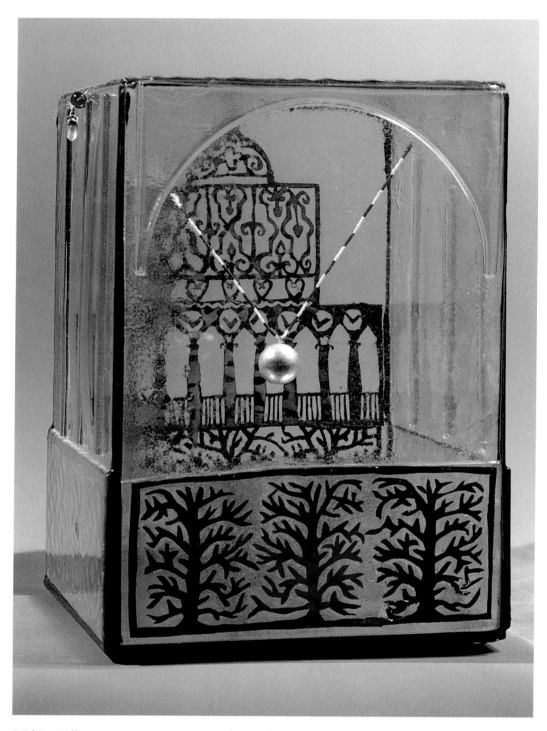

Wishing Well, 1999, 15"ʜ × 10"ᴡ × 12"ᴅ. Sculpture of fused glass and mixed media.

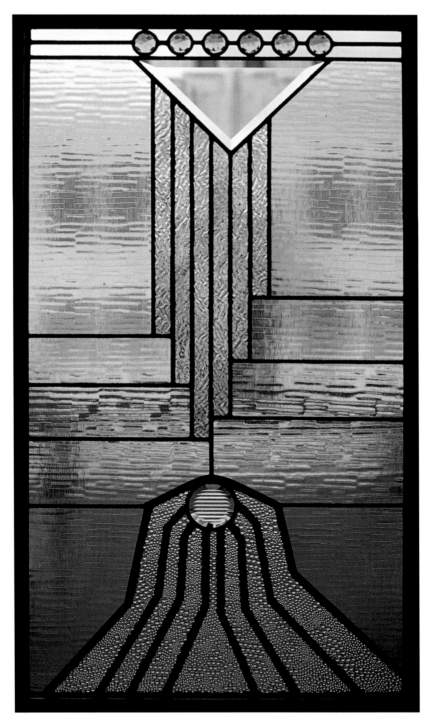

Daylife, 40"H × 24"W. Stained and leaded glass panel with clear, textured and beveled glass. Amber jewels and iridized ripple. Golden pine frame.

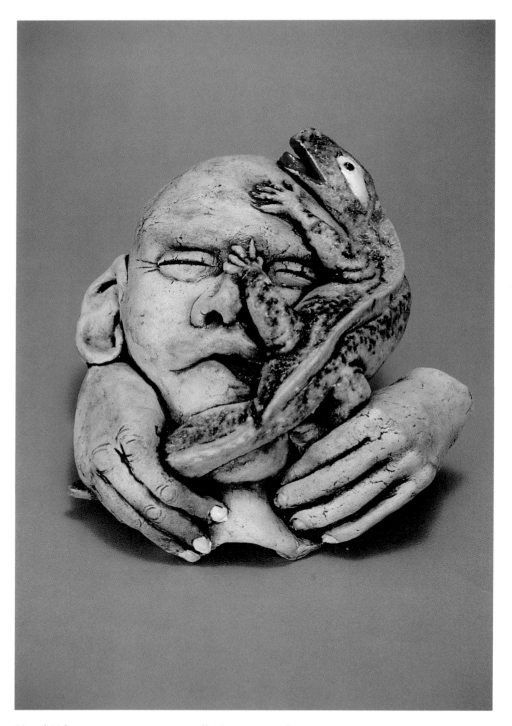

Lizard Licker, 10"H × 8"W × 4"D. Handbuilt ceramic sculpture. Courtesy of Lakeside Gallery.

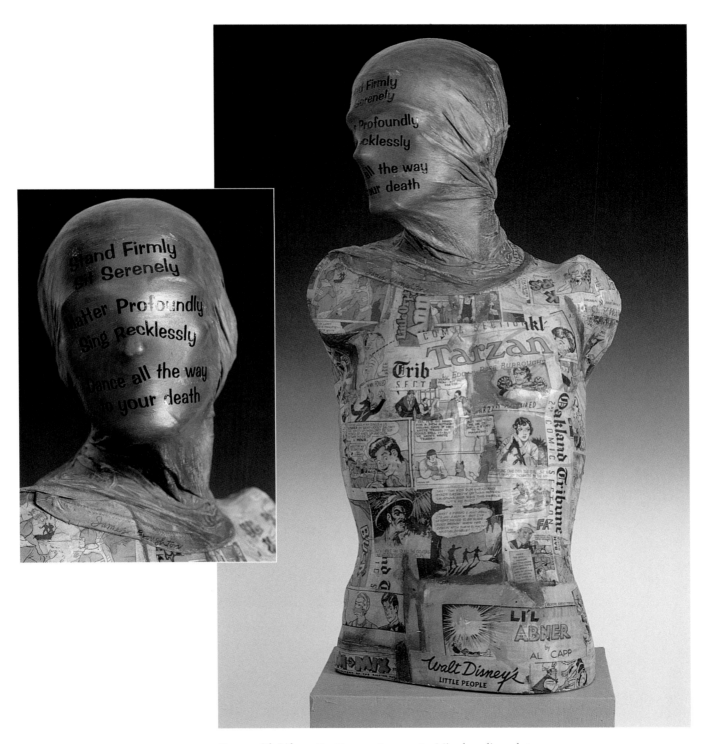

Dance with Life, 1998, 48"H × 24"W × 24"D. Mixed media sculpture.

Forest Path Gem, 7"ʜ × 8"ᴡ × 8"ᴅ. Stitched and painted fiber vessel.

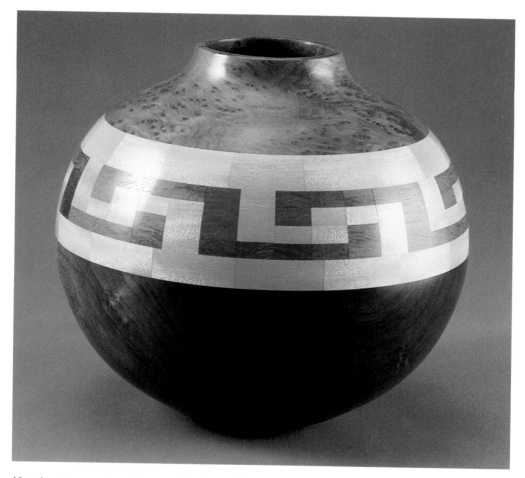

Navajo, 10"H × 10"DIA. Segmented and turned from walnut, padauk, yellowheart and redwood. Photo by Bob Hawks.

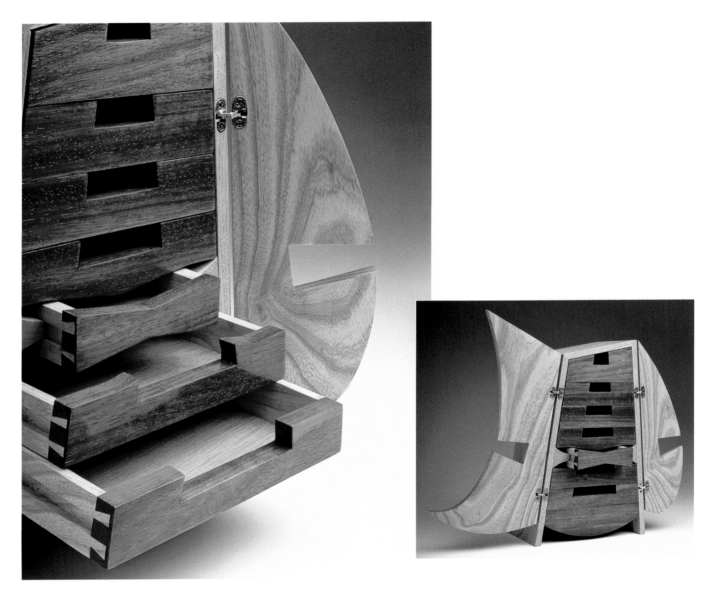

Bowtie Box, 17"H × 10"W × 7"D. Cabinet made from ash with padauk wood drawer fronts. Dovetailed drawers with wooden slides.

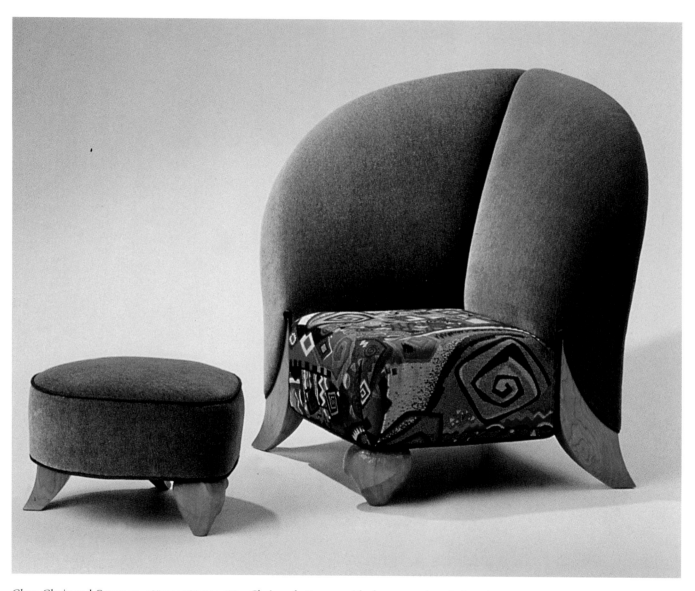

Clove Chair and Ottoman, 48"H × 38"W × 38"D. Chair and ottoman with cherry wood, mohair and tapestry seat. Photo by T. Brummett.

Chair, 1999, 48"ʜ × 60"ᴡ. Mixed media on wood.

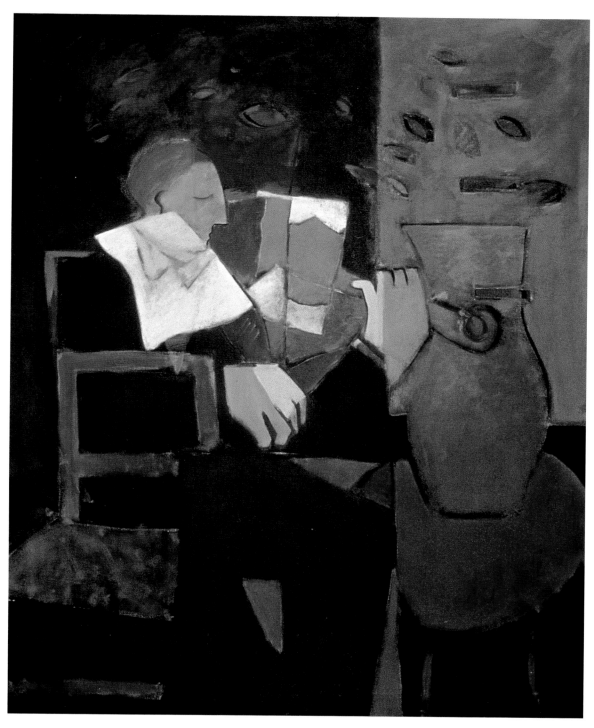

Music in Detail, 2000, 50"H × 40"W. Acrylic on canvas.

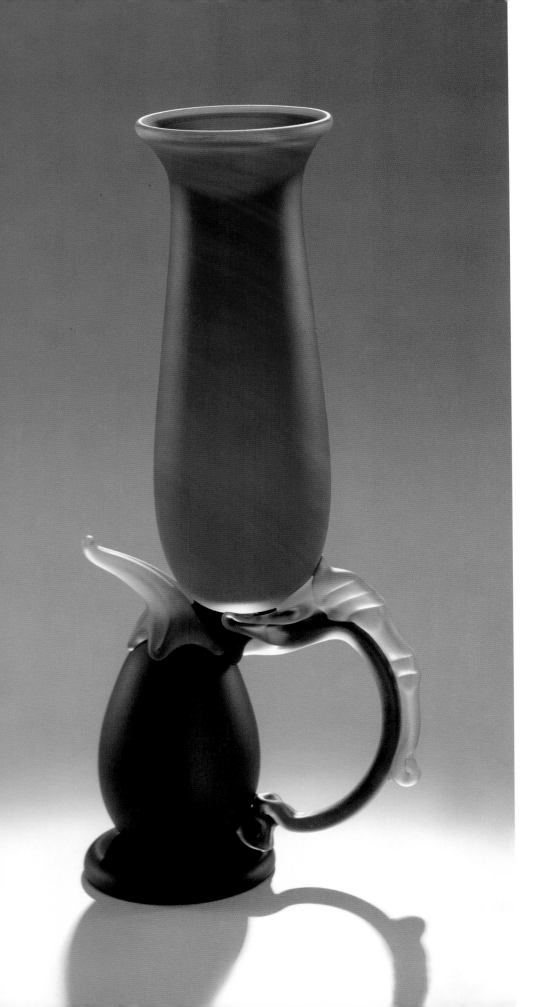

WORD OF MOUTH
ON OBJECTS OF ORAL DEIGHT

ESSAY AND COLLECTION BY SUZANNE RAMLJAK

If eyes are the window to the soul, as the adage goes, then the mouth is the portal to the body. The most essential orifice for human survival, the mouth provides sustenance and critical sensory input. Even before we can see, we experience the world through our mouths; biologists have shown that "from fish to humans, the oral region is the earliest part of the body to become sensitive to cutaneous stimulation."[1] During the first year of life, suckling is our most vital activity, and according to Freud, the encompassing pleasure of this early oral stage serves as a measure of our future satisfaction.

We spend our entire lives administering things orally, mainly to meet nutritional needs, but also as a source of stimulation. Dozens of times daily we bring things to our mouth, usually without much regard for the sensual quality of the experience. Especially today in our fast-paced culture, it is easy to ignore the call of our senses, and in spite of rampant oral fixations — from smoking to nail biting — the mouth remains a site of relative neglect. This poverty of oral stimuli is unfortunate, given that our mouths are equipped with a greater number of sensory nerve endings than any other part of the body (except perhaps the fingertips).[2] The mouth cries out to be pacified and to receive the pleasure it was designed for.

Of course, kissing can help to pacify our mouths (humans are unique among mammals in treating the kiss as a recreational pastime), and our need for oral sensation is also fulfilled through the texture and flavor of the foods that we eat. But we can turn to objects to supplement our experience and make the act of consumption more satisfying. Fortunately, there are many engaging "oral objects" — items we put in our mouths or to our lips such as cups and glasses, spoons and forks — that can add to the mouth's gratification. These commonplace objects that we employ every day have great potential to affect our sense of physical well-being.

There are various ways that such objects can captivate us and help us linger in the oral realm. One of the most direct ways to involve users is through decorative embellishment. Conducive motifs include ripe fruits and vegetables, and figures absorbed in languor

OPPOSITE
Robert Levin, *Eggplant Goblet,* ©2001, 11.5"H × 4.5"w. Handblown goblet with hot-formed, sculpted elements.

[1] Ashley Montagu, *Touching: The Human Significance of the Skin* (New York: Harper & Row, 1971), 115.
[2] Montagu, 116.

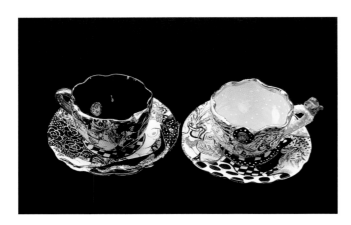

LANEY K. OXMAN, *Jumbo Teacups*. With their rippling lips, sensuous imagery and large-bodied bowls, these teacups are designed to engage our mouths more deeply in the experience of drinking.

or play. This iconography of pleasure encourages one to slow down and focus on the surface of a vessel or implement each time it is brought to the lips.

Another way an object can engage us more fully is by complicating the process of function or use. The more difficult an object is to employ, the more mindful our interaction with it is likely to be. By setting an element off-kilter, that is, one can call attention to an otherwise overlooked act. Artists employ different tactics to disrupt our habitual practices, such as increasing an object's scale to force us to open our mouths wider or more carefully or exaggerating the weight of a vessel or flatware to put more pressure on lips and tongue.

A related category of objects is that of ceremonial ware, or items designed for special occasions. Works in this vein include chalices, offering cups, Sabbath cups, goblets, serving trays and implements. All cultures have treated eating as a form of ritual, and we are increasingly losing the larger social value of this essential human activity. Through the use of rare materials, elaborate designs, and the inclusion of text,

ceremonial items compel us to concentrate on the act of taking substances into our bodies. Drawing attention to the symbolic dimension of ingestion, such objects encourage us to meditate while we consume.

Other objects rely less on symbolism and are calibrated instead to afford the maximum amount of pleasure and stimulation. These items are crafted with a keen understanding of the human anatomy. As we insert the lip of a well-made cup or glass into our mouths, we are rewarded with a gentle swell or a subtle texture; we are invited to dwell on the surface or follow the curve of the rim. In the same way, a finely contoured spoon or the prongs of a fork can entice us to savor the process of putting things in our mouths.

Sensitively made oral objects take their place in a larger symphony of physical sensation. The act of consumption is a multisensory experience involving sight, smell, taste and touch. When we lift up a vessel to drink, the feel of the handle and the color of the glass or glaze prepare the tongue for tasting. The stimula-

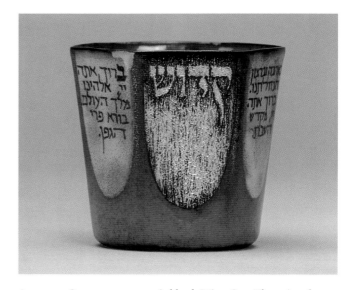

ARNOLD SCHWARZBART, *Sabbath Wine Cup*. The painted Sabbath prayer on this ceremonial vessel encourages users to place their mouths upon worshipful words and contemplate the ritual act of consuming wine.

tion of one sense arouses that of another, creating an intricate mix of sensory input. Just as the smell, appearance and weight of food all impact our sense of taste, the physical properties of the implements we use affect the experience of our food.

There is also much representational art, which appeals indirectly to the mouth by means of the eyes. Still lifes in particular seduce us with images of edible goods. Through realistic detail, carefully placed objects, and a strategic vantage point, the viewer is beckoned into the scene. These painted delights allow us the vicarious pleasure of consuming what lies before us.

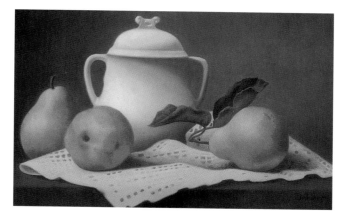

LEAH KRISTIN DAHLGREN, *Three Pears with Sugar Bowl.* This traditional still life enlists realistic detail, life-size painted fruit, and a carefully angled table to vicariously appeal to the viewer's hand and mouth.

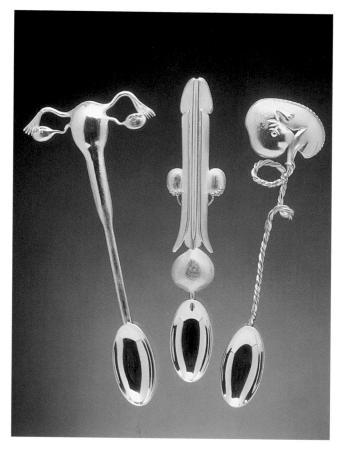

BORIS BALLY, *Reproduction: He Spoon, She Spoon, We Spoon.* In the process of using these elaborate spoons we are reminded of the biological facts of life: consumption, sex and regeneration. Photo by Dean Powell.

Whether in two or three dimensions, well-crafted objects have the power to refresh our senses and engage us more fully in our daily experience. Speaking of the power of decorative arts, William Morris declared: "it is one of the chief uses of decoration, the chief part of its alliance with nature, that it has to sharpen our dulled senses . . . for this end are those wonders of intricate patterns interwoven, those strange forms invented, which men have so long delighted in."[3] Sensory enhancement is precisely the aim of a finely tuned oral object. Such items can serve as tools for greater self-knowledge. Above all, they can teach us to pay more attention and to stay present at the banquet of our lives.

Suzanne Ramljak is an art historian, writer and curator with a specialty in the field of 20th-century art and has worked in the curatorial departments of various museums. She is editor of *Metalsmith* magazine, as well as former editor of *Sculpture* and *Glass* magazines and former associate editor of *American Ceramics* magazine.

[1] William Morris, "The Lesser Arts," *News from Nowhere and Other Writings.* (New York: Penguin, 1993), 235.

To

Kiss

Your

Lips

To Kiss Your Lips, 1998, 16"H × 16"W. Suite of four etchings. Courtesy of Landfall Press, Inc.

Natura Morta, 2000, 20"H × 11"DIA. Three-tiered lampworked glass fruit platter with gold leaf accents, glass fruit and figures. Courtesy of Mostly Glass Gallery.

Still Life with Bowl of Fruit, 23"H × 35"W. Giclée print on Somerset paper.

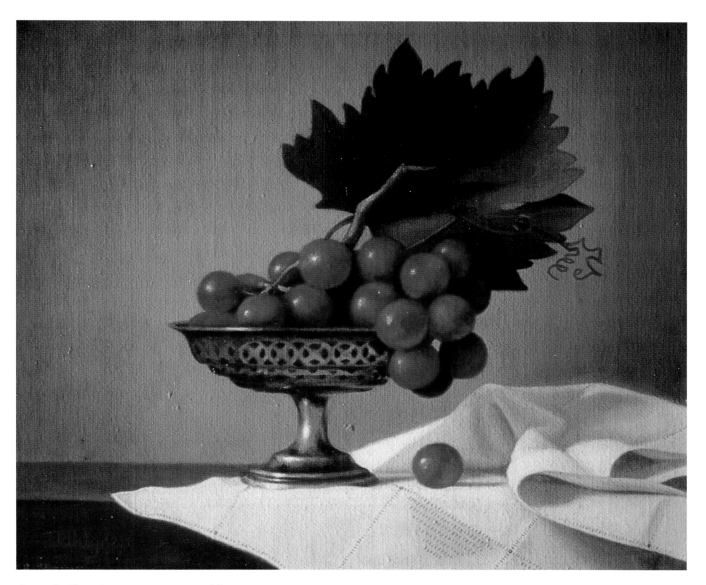

Grapes in Silver Compote, 8"H × 10"w. Oil on canvas.

PHYLLIS S. CLARKE

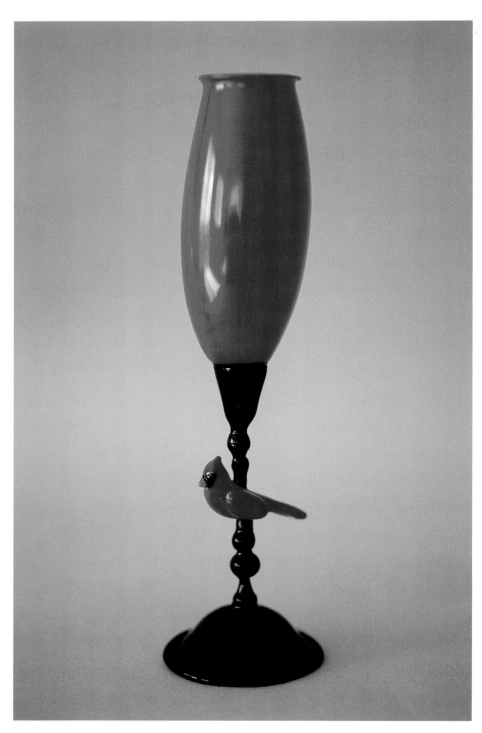

Cardinal Goblet, 7"ʜ × 2"ᴡ × 2"ᴅ. Blown glass goblet with lampworked cardinal on stem.
Photo by Richard Clarke.

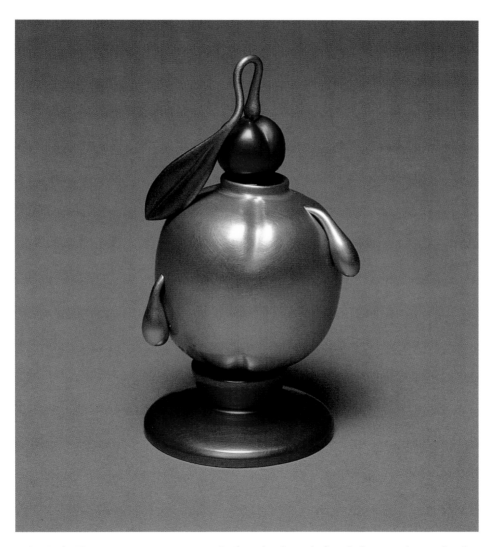

Juicy Fruits II, 1996, 3"H × 1.5"W × 1.5"D. Perfume bottle made from lathe-turned, carved and anodized aluminum. Interior is lined with glass. Applicator is a blueberry of lampworked glass.
Photo by Hyperion Studios.

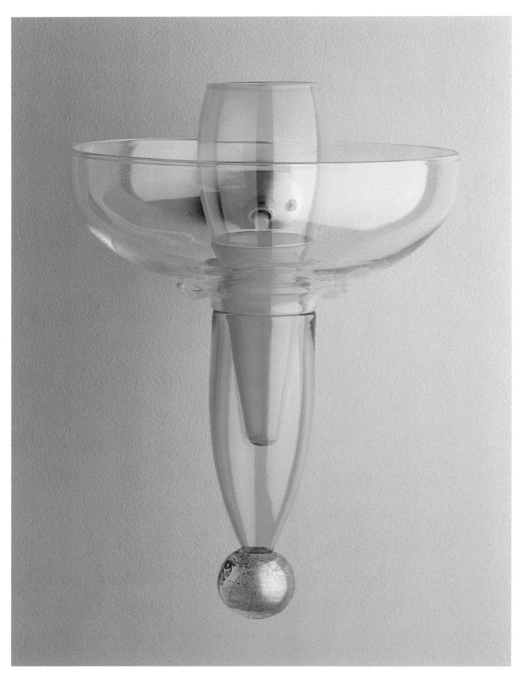

Floating Champagne (Guanajuato), 8"ʜ × 5.5"ᴡ × 5.5"ᴅ. Two-piece floating champagne glass blown by hand. Photo by Roger Schreiber.

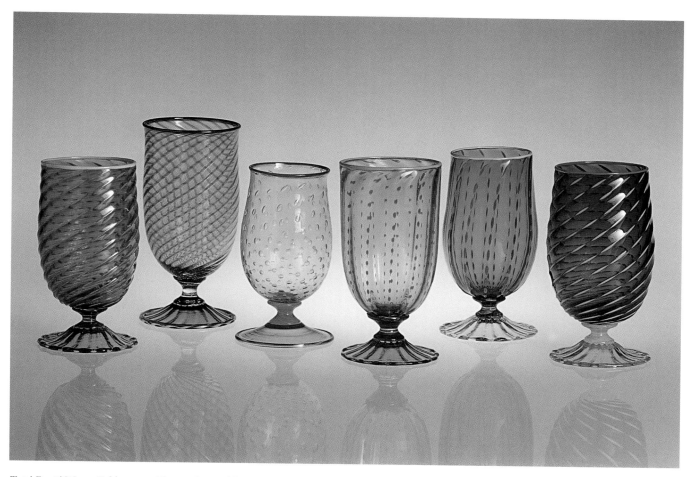

Tutti Frutti Water Goblets, 6"H. Blown glass goblets made with multiple techniques of hot-forming glass, inspired by the Venetian tradition.

Chopsticks with Stand, 8"H × 0.25"W × 0.25"D. Chopsticks and stand of forged sterling silver. Photo by Peter Groesbeck.

Trussware, 8"H × 2"W × 0.5"D. Four-piece silver place setting inspired by raw ceiling beams. Photo by Dean Powell.

Espresso Cup and Saucer, 3.25"H × 6.5"W. Cup and saucer made from red earthenware clay, wheel thrown with colored slips and underglaze decoration.

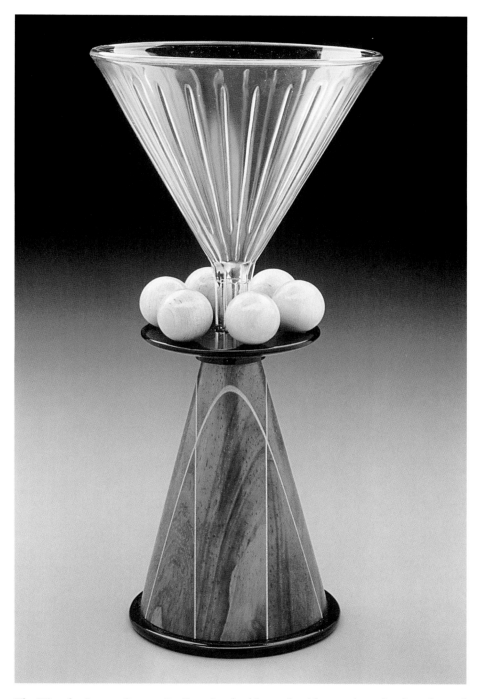

The Wizard, 11"ʜ × 5.5"ᴡ × 5.5"ᴅ. Functional goblet made with an antique glass funnel as well as padauk, maple and ebony. Photo by Dean Powell.

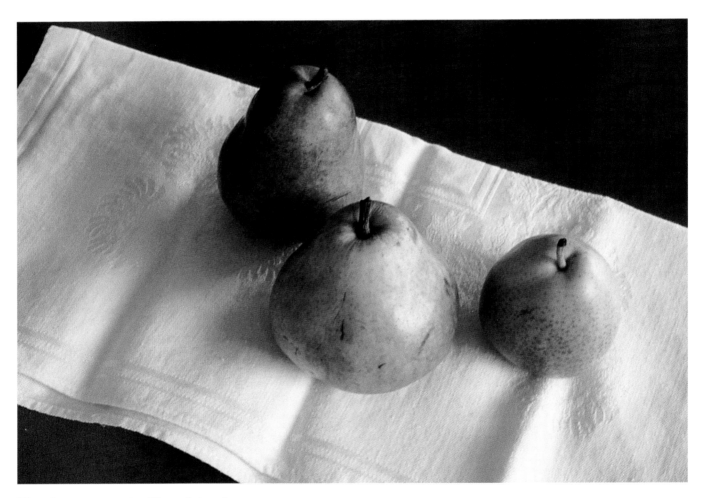

Three Pears, 16"H × 20"W. Silver gelatin print.

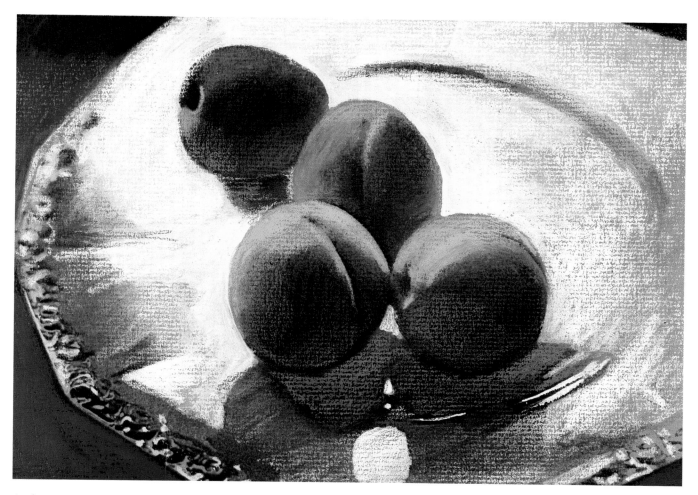

Apricots, 13.5"H × 20"W. Digital art print of an original mixed-media painting.

CATHI JEFFERSON

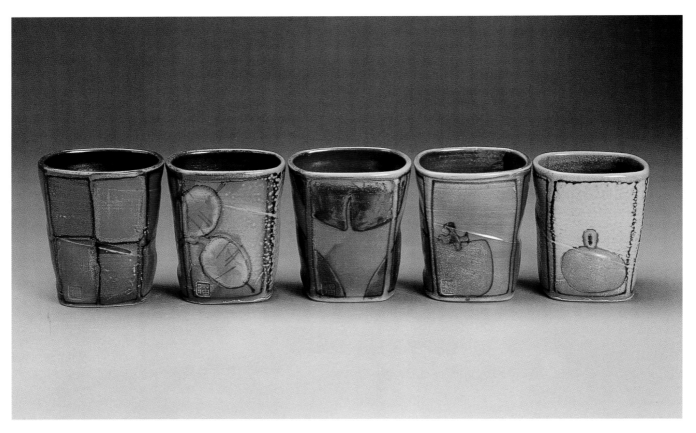

Wine/Scotch Cup Set, 3.5"H × 3"DIA. Wheel-thrown and salt-fired ceramic cups.

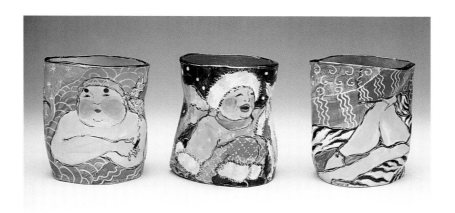

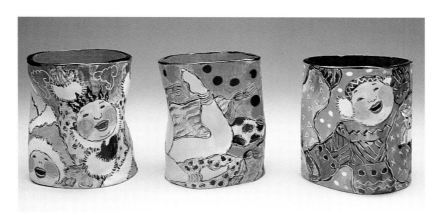

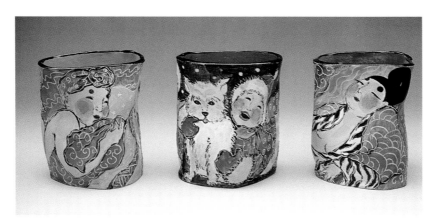

Cups, 4"H × 3.5"DIA. Sculpted earthenware cups decorated with underglaze colors and sgraffito. Photo by James Dee.

Pie, 15"H × 19"H. Giclée print of an original watercolor painting. Photo by Geri Bauer Photographics, Inc.

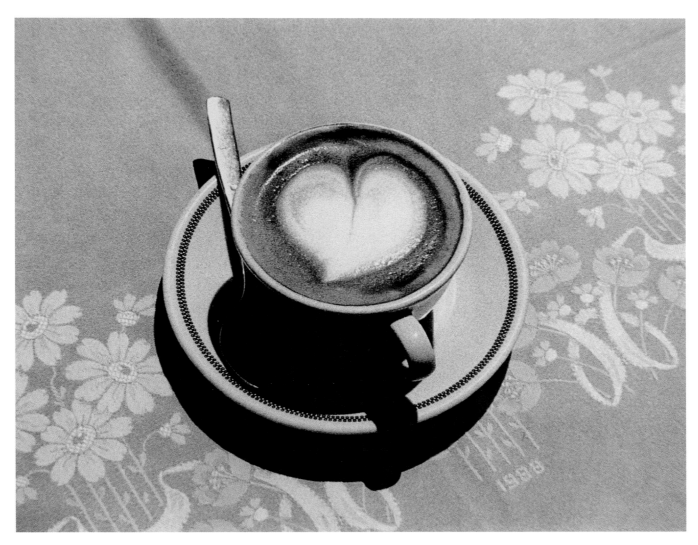

Cappuccino — Rome, Italy, 18"H × 22"W × 0.5"D. Archival digital print. The black-and-white negative is scanned, digitally painted and toned.

CHRISTINE RODIN

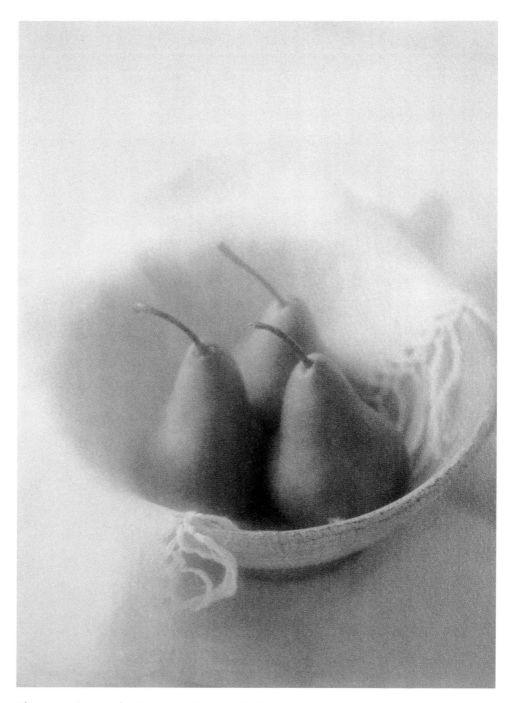

Three Pears in a Bowl, 10"H × 8"w. Sepia-toned silver gelatin print.

168

TOP: *Skin #2,* 22"H × 28"w. Cibachrome photograph.
BOTTOM: *Cosmic Peaches,* 22"H × 28"w. Cibachrome photograph.

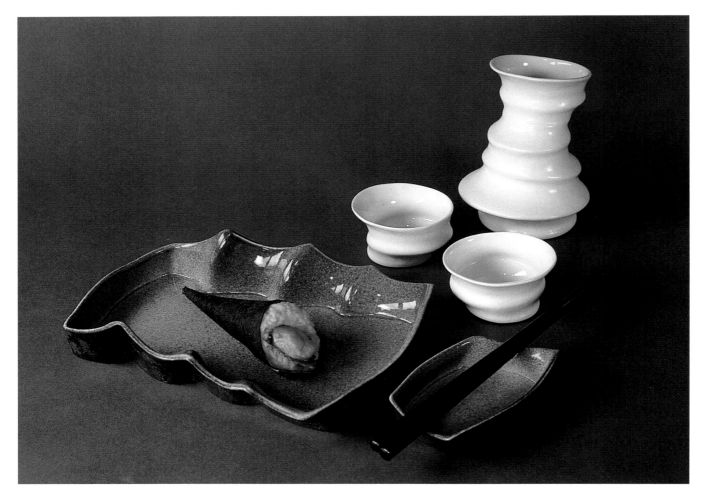

Sushi Set, plate (2"H × 8.5"W × 6.5"D), soy dish (1"H × 4"W × 2.5"D), pitcher (5"H × 4"DIA), cups (1.5"H × 3"DIA). Cast porcelain sushi and sake sets. Photo by Kaete Brittin Shaw.

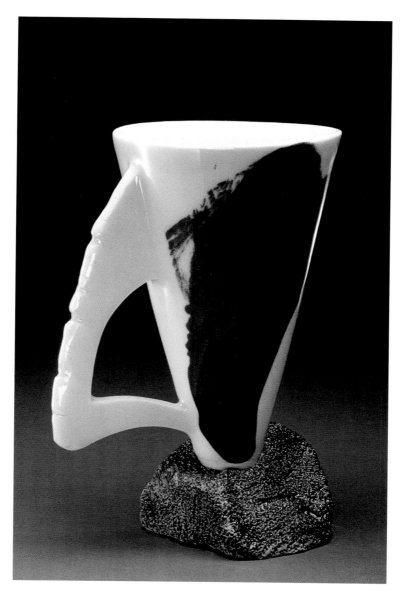

Cone Shape Cup, 1999, 8"H × 7"W × 4"D. Sculptural and functional porcelain cup.

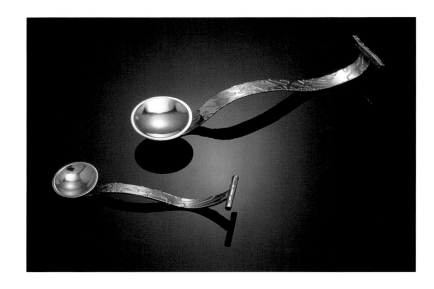

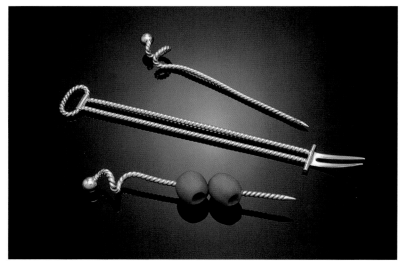

TOP: *Bon Bon Server/Baby Demi-Tasse*, 3.5" L to 6" L. Fabricated and acid-etched sterling silver spoons. Photo by Bart Kasten.
BOTTOM: *Martini Olive Picks*, 4"L to 6"L. Hand-fabricated sterling silver olive and martini picks. Photo by Bart Kasten.

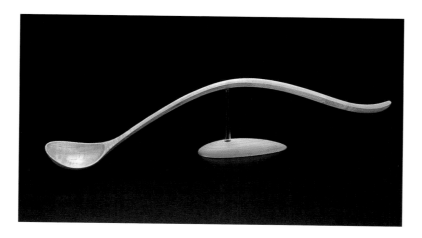

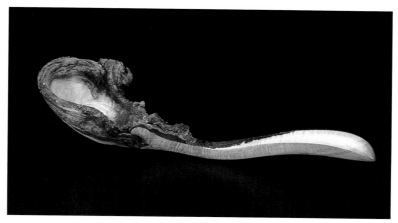

Top: *Spoon with Stand*, 1996, 6"H × 3"W × 22"L. Spoon and stand made from hard maple. Photo by Rudy Hellmann.
Bottom: *Cave Dweller Spoon*, 1998, 4"H × 5"W × 18"L. Spoon made from hard maple. Photo by Rudy Hellmann.

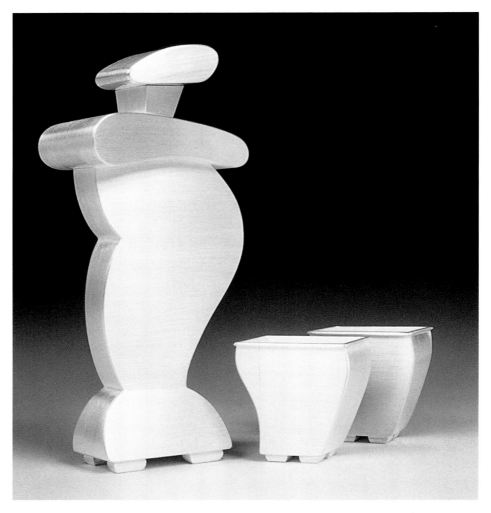

Fort Davis Decanter, 1991, 6.5"H × 2.75"W × 1.75"D. Fabricated sterling silver decanter, lid and two cups. Photo by Nancy Slagle.

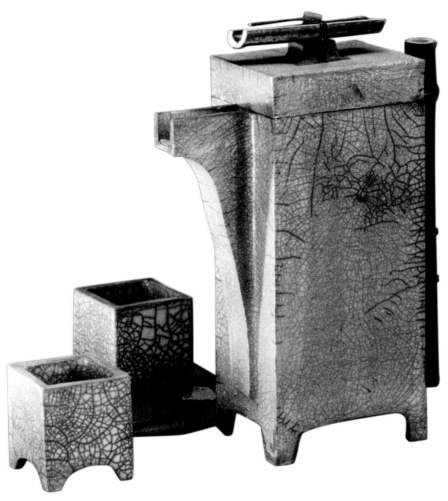

Teapot with Two Cups, teapot (10.5"H × 5"W × 3"D), cups (2"H × 1.5"W × 1.5"D). Raku-fired teapot with two cups. Filtered teapot has a black bamboo handle embellished with a red coral bead. Photo by Frank Wing.

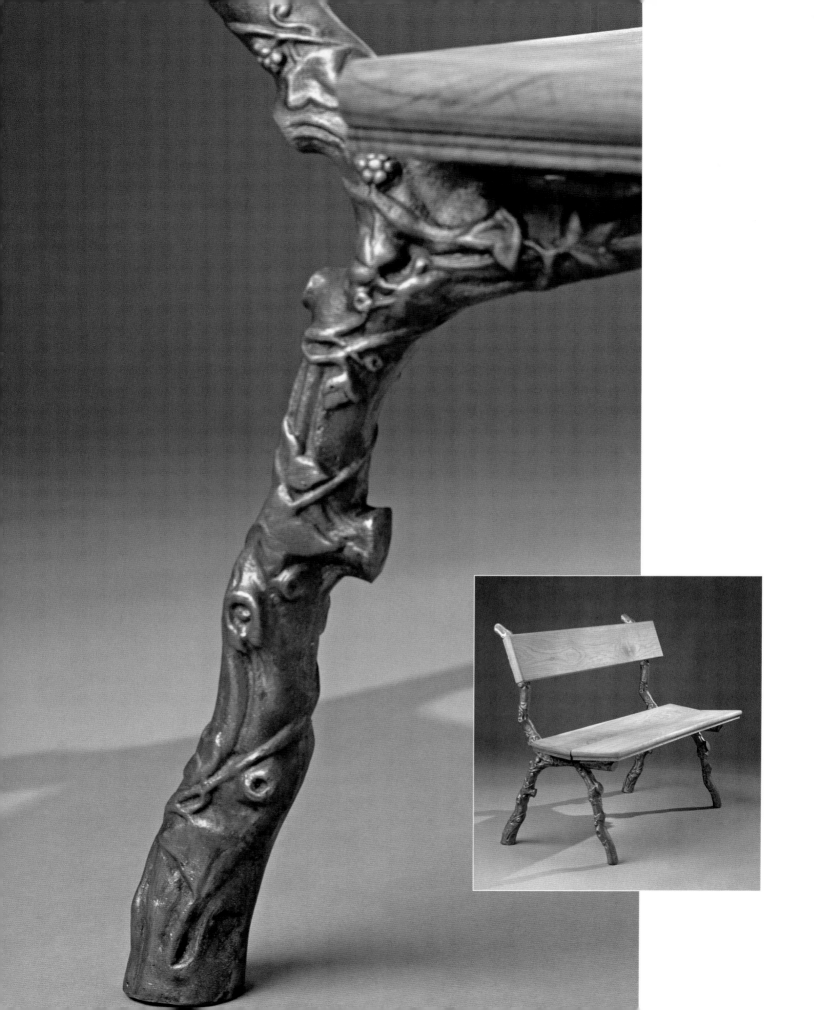

SITTING PRETTY
THE CHAIR AS AN OBJECT OF ATTENTION

ESSAY AND COLLECTION BY KAREN S. CHAMBERS

Chairs. You're probably sitting in one as you read this, unless you are kneeling on a tatami mat or lolling on a carpet in a Bedouin tent or sprawling on a picnic blanket in the park. If you are a Westerner or Westernized, it is likely that a chair — or some cognate of it such as a sofa — is where you have settled to leaf through this book.

Unless they are uncomfortable, we tend to take chairs for granted. They exist to support our bodies, so we ask that they be sturdy and steady — but then we quickly ask more. We ask them to express our sense of style, our aesthetics. Are we modernists, opting for Marcel Breuer's *Wassily Club Chair,* or traditionalists preferring a wing chair? We expect chairs to express our personalities — a dainty slipper chair for a lady's boudoir or a La-Z-Boy recliner for the man of the house. Chairs also symbolize power, be it the gilded throne of a queen or the carved stool of an African chieftain. It doesn't take much for chair to become metaphor. In fact, the chair's potential for meaning beyond mere functionality exceeds that of many other common objects. For example, a tree can symbolize the whole of nature or take on human traits. Similarly, a dwelling can take on an array of meanings. Yet a chair focuses our associations with the natural and the domestic, speaking concisely and elegantly of life and how it is lived.

In *Walden,* Henry David Thoreau wrote that he had three chairs in his house: "one for solitude, two for friendship, three for society." Marlies Merk Najaka's giclée print of her watercolor painting titled *Chairs* (below) has three chairs for society. The three white Adirondack chairs have

MARLIES MERK NAJAKA, *Chairs.* The three Adirondack chairs in Marlies Merk Najaka's image are not occupied, but one can imagine the lazy-summer-day conversation that might have taken place, and the sense of community the absent sitters had, in the gentle sunshine.

turned their backs on the viewer. (How we like to anthropomorphize the chair, talking about its back, its leg, its arm, its seat.) The chairs represent three people, who may have just left, or perhaps will come to occupy them. We

OPPOSITE

Daphne Bench, 31"H × 48"W × 14"D. Cast bronze and hardwood bench. Photo by Jim Wildeman.

LEFT: CHRIS BOISSEVAIN AND ERIC ZIEMELIS, *Modern Adirondack Chair*. The elements of a traditional Adirondack chair, originally made at the turn of the 20th century (often by do-it-yourselfers), have been translated into the modernist idiom by Chris Boissevain and Eric Ziemelis. Photo by Chris Boissevain.

RIGHT: DONALD JUDD, *Arm Chair*. Donald Judd's aluminum *Arm Chair* might be seen as being artless in its minimalism, as it distills a familiar form into simple blocks. However, the relationship of arm height to seat and seat to shelf reveals an absolutely meticulous sense of proportion. Courtesy of A/D.

can imagine them, or ourselves, sitting on them on a summer day; we feel the wooden slats of the chair and the deep seat as we settle back into the comforting form, the arms just the right height to support our arms and the right width for a glass of iced tea, while we enjoy the warmth of the sun or the coolness of the breeze.

Najaka's traditional Adirondack chairs, then, evoke a certain emotional response, quite unlike that of a similar configuration of aluminum lawn chairs situated in the same landscape. When she paints the vernacular chairs that were originally made at the turn of the 20th century, often as do-it-yourself projects using readily available milled wood, Najaka counts on that emotional response. She is not drawn to them for their formal appearance alone, as was the late sculptor Scott Burton, who replicated an Adirondack chair in Formica. Chris Boissevain and Eric Ziemelis's interpretation of the traditional form, by contrast, does focus on form itself. Their *Modern*

Adirondack Chair is made of steel and wetsuit material. The two San Francisco-based sculptors, who began making furniture a decade ago, have distilled the form to its essence — a slanting back, a deep and wide seat, comforting arms. But this is a modernist take. Boissevain and Ziemelis follow the Mies van der Rohe mantra that "less is more" and use industrial materials just as Mies did in his clean-lined furniture.

Boissevain and Ziemelis's formalist approach was also espoused by the late critic-turned-artist Donald Judd, who applied his minimalist aesthetic to furniture as well as to sculpture. Just as Judd reduced sculpture to basic geometric forms, he did the same with furniture (originally designing it for his own use). Instead of adding grace to the straightforward form of a chair, as Boissevain and Ziemelis did when they substituted a curving arc for the right-angled arms of the traditional Adirondack, Judd went for the most austere rendition of a chair in his aluminum *Arm Chair*. He adheres to the modernist "form follows function" dictum in an uncompromising manner and — one suspects — an uncomfortable fashion. Yet there is a majesty about his blocky *Arm Chair,* with its

CAT GWYNN, *Chairs*. When Cat Gwynn photographed these chairs on their own level, she elevated their meaning. Instead of just nondescript chairs in an anonymous setting, they have such "personality" that the viewer is invited to imagine what social situation they might be engaged in.

strict geometry. Its spare elegance brings to mind the thrones medieval manuscript painters created for Christ.

The simplicity that characterizes Judd's *Arm Chair* ties it to the straight chairs that Cat Gwynn has photographed in *Chairs*. She has recorded in black and white an arrangement of unremarkable chairs — unremarkable, that is, except for the mystery with which Gwynn has surrounded them. She has photographed them from a low vantage point, changing the perspective from which the chairs are usually viewed and making them the actors in a tableau. Lined up against a window, the three chairs — again, Thoreau's three for society — seem crowned by fantastic headdresses, the ghostly trees seen through the picture window. They may be the attendants — the supporting cast — for the chairs that loom large in the foreground. The artist writes, ". . . it's what is in-between the lines that intrigues me most. To capture an extraordinary moment with the context of something familiar."

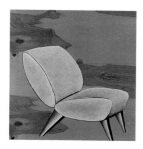

STEVEN SHORES, *Chair*. Steven Shores places a mid-20th century modern chair front and center in *Chair*. The biomorphic forms of the 1950s become even more abstract as Shores assembles them into a recognizable chair form silhouetted against a background of wood grain that may represent a floor.

Just as Gwynn turns her straight chairs into actors in a drama, painter Steven Shores gives us a portrait with his generically titled *Chair*. It is easy to imagine that this is a figure, turned slightly toward the viewer but gazing off into the distance. And just as an unnamed sitter is revealed through the details a painter chooses to include — how the sitter is attired, what surrounds him, and even how much of the canvas is taken up by the subject — so does Shores give us a sense of the personality of this midcentury chair. It is stylish and assertive as it thrusts its

cushions forward. Its back leg does not seem to taper to a blunted point, but rather expands in bulk, perhaps a tad too much for proportional harmony, but just right as an expression of forceful personality.

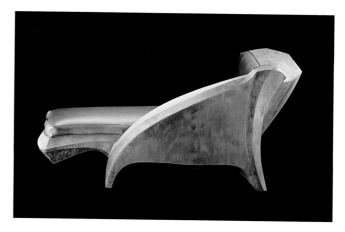

SEAN CALYER, *Chaise Lounge*. The graceful forms of Sean Calyer's *Chaise Lounge* recall the neoclassicist Jacques-Louis David's *Madame Recamier*, painted in 1800.
Courtesy of Handsel Gallery. Photo by Bruce Miller.

One "knows" Shores's *Chair* as well as one does Sean Calyer's *Chaise Lounge*, a sensual figure in a languorous mood. The sweep of the mild steel arm is as elegant as the elongated arm and generous back of Ingres's portrait of the Grand Odalisque, the leather upholstery as smooth as her flesh. How Calyer juxtaposes the curving forms of the arm and base — the body — of the chaise lounge makes it as much a sculpture as a functional form. Just as Scott Burton and other furniture artists have done, Calyer has taken a usable object and turned it into an artistic statement.

So, while "a rose is a rose is a rose," a chair is not always just a chair.

Trained as an art historian with a master of arts degree from the University of Cincinnati, Karen S. Chambers has held curatorial positions at various museums, worked in contemporary art galleries in New York and written extensively on the fine and applied arts. As an independent curator, she organizes exhibitions and lectures frequently on a variety of art, craft and design topics.

Salon of Eternal Souls, 1996, 57"H × 43"w. Color lithograph. Courtesy of Landfall Press, Inc.

Remnants, 1994, 20"ʜ × 24"ᴡ. Graphite on paper.

Poles and Aspens, 1996, 15"H × 15"w. Silver gelatin print.

Winter #1, 16"H × 20"W. Ifochrome photograph.

No Bed of Roses, 33"H × 44"W. Quilted and appliquéd art quilt.

He Was Different from the Others, 12"H × 6"W × 4"D. Sand-cast glass sculpture with found objects, gold leaf, plate shard, copper patina and engraved single-strength windowpane.

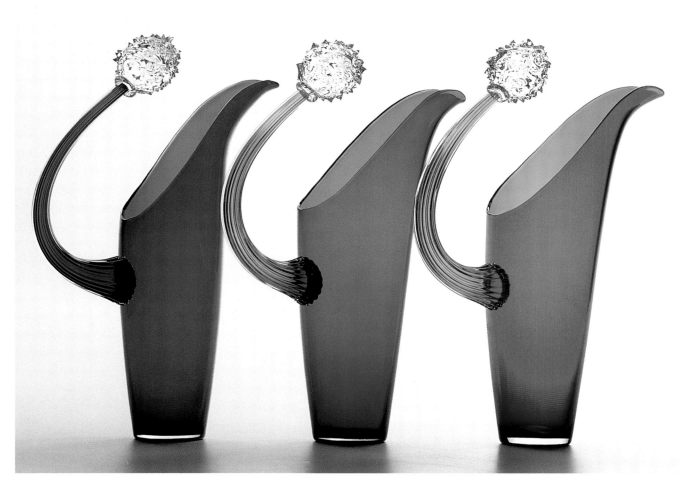

Mace Pitcher, 13"H × 8.5"W × 3.25"D. Pitcher or vase made from blown and sculpted hot glass. Photo by Russell Johnson.

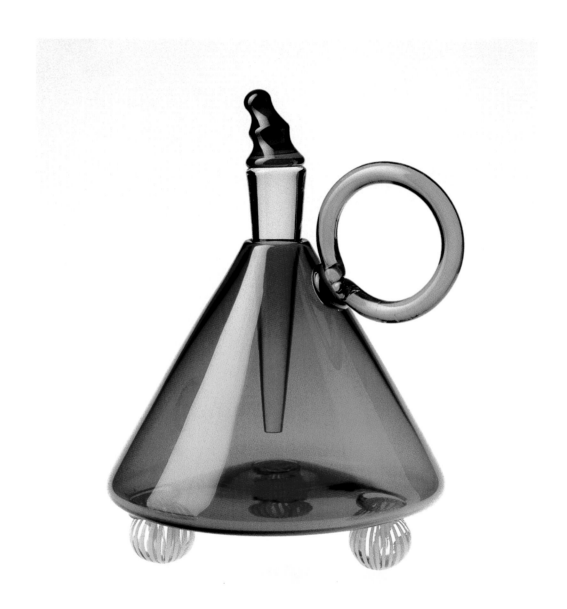

Handle on This, 13"H × 8"W. Blown glass cone with stopper. Individual elements assembled while still hot.
Photo by Charlie Parker.

Arc End Table, 26"H × 22"W × 24"D. End table made of cherry wood, steel and glass. Photo by Chris Boissevain.

Modulus Type 1, 36"H × 25"W × 28"D. Chair made with recycled bicycle rims and inner tubes. Photo by Andrew Gregg.

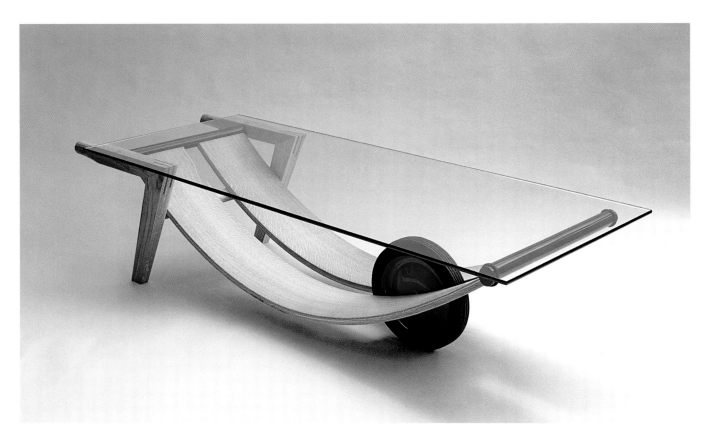

The Gardener's Table, 16.5"H × 24"W × 65"D. Mobile table made of white oak and steel, with a bent, laminated oak body and hand-hewn handles. Photo by John McDermott.

Long & Short Tables, short table (22"H × 26.5"W × 13"D), long table (25.5"H × 36"W × 14"D). Tables made from reused traffic signs, glass, copper rivets and fasteners. Photo by Dean Powell.

Triped, 20"H × 11"W × 11"D. Set of three stackable tables of bubinga, maple and mahogany with stainless steel legs. Photo by Dean Powell.

Bird Table, 21"H × 24"W × 21"D. Kinetic mahogany table finished with oil. Photo by Dean Powell.

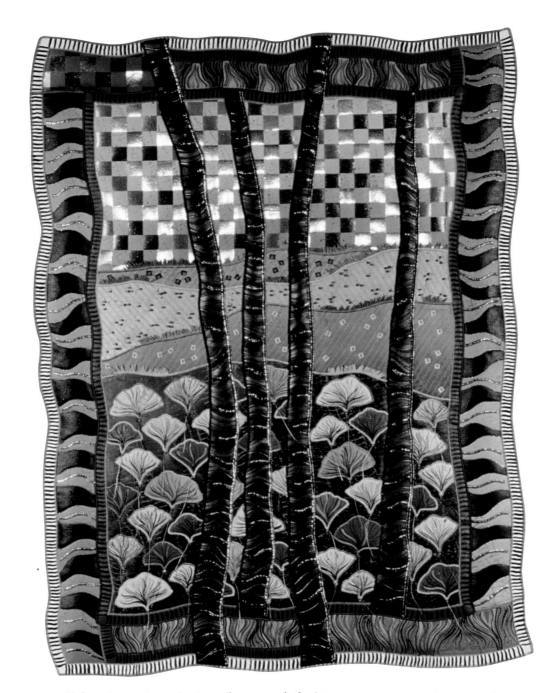

Ginko, 43"H × 32"W × 1"D. Art quilt composed of paint on sewn canvas. Photo by Tim Barnwell.

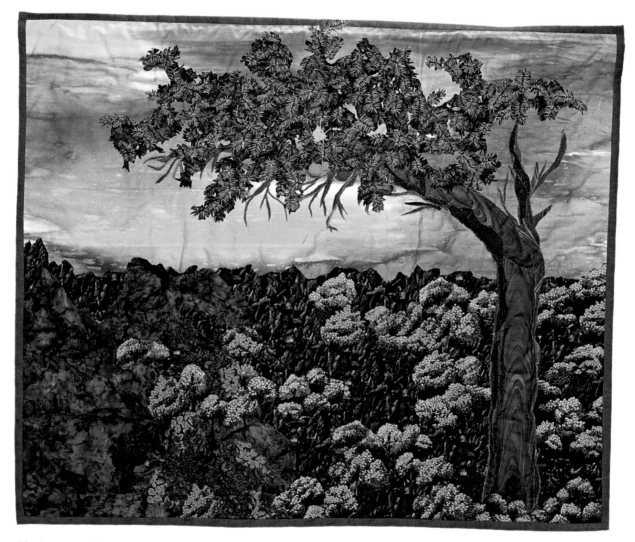

The Lonesome Pine, 1999, 30"H × 34.5"W. Art quilt made of machine-pieced cotton. Photo by Rich Miller.

12 Pitchers, 1992, 28"H × 20"W. Oil, acrylic, gold leaf and sand on wood panel. Photo by Michael Eade.

Hog Series CXXXVII, 1996, 20"H × 16"W. Mixed media on museum board.

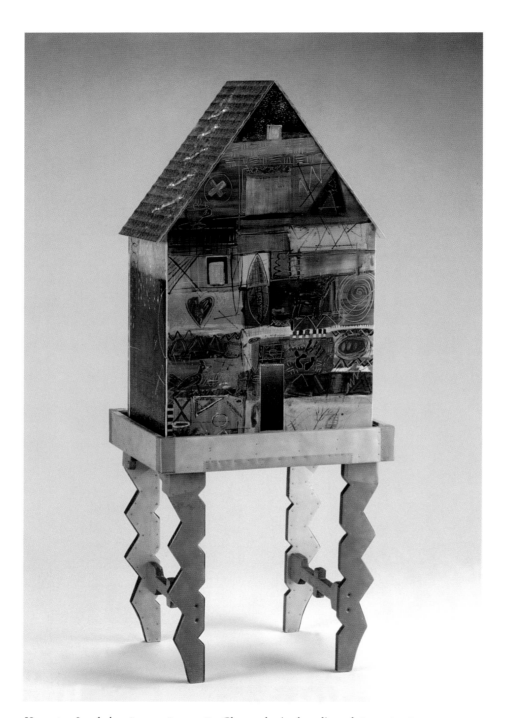

Homestay Lombok, 52"ʜ × 19"ᴡ × 14"ᴅ. Glass and mixed media sculpture. Photo by Lee Fatherree.

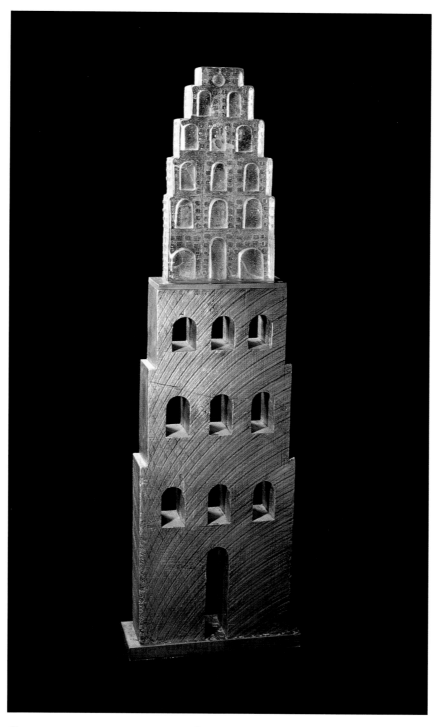

Circa, 1998, 60"н × 18"w × 6"ᴅ. Cast glass sculpture of a ziggurat with a lower section of wood and base of steel. Photo by Mark Kobasz.

Chicago Loop, 8"H × 10"W. Silver gelatin print.

Obelisk (Pittsburgh Bowling Monument, PA), 6"H × 9"w. Silver gelatin print.

Toshahatchee State Reserve, 1994, 8"H × 10"W. Silver gelatin print.

The Art of Silence, 16"H × 20"W. Ilfochrome photograph.

MICHAEL A. BURNS

Dragonfly Table, 36"H × 68"W × 18"D.
Table made of fabricated steel with patinated
finish and inlaid silver, gemstones and gold.

The Nest, 61.5"H × 16.5"W × 14.5"D. Fabricated bronze sculpture

ABOUT THE ARTISTS

■ **JACKIE ABRAMS**

Jackie Abrams's baskets are woven of heavyweight watercolor paper that she has decorated with painting, collage and print-making surface techniques. Each piece is created with a focus on the interplay of color, texture and surface design. ■ PAGE 140

■ **JEANETTE AHLGREN**

Jeanette Ahlgren makes freestanding basket forms by weaving thousands of glass beads onto structures of finely woven brass, copper or stainless steel wire. The beads combine to form a tiny, brilliant tapestry of geometric or landscape images. ■ PAGE 78

■ **DIANE ECHNOZ ALMEYDA**

Diane Echnoz Almeyda has always loved working with metals, but wanted a larger color palette. Her solution: plique-a-jour. The extensive metalwork skeleton and endless variety of colors possible with enamels give her a broad base on which to build intricate and colorful vessels reminiscent of the high-quality treasures made during plique-a-jour's heyday. ■ PAGE 125

■ **DINA ANGEL-WING**

Dynamically balancing teapot bodies with spouts, lids and handles is one of Dina Angel-Wing's main creative challenges. She uses black bamboo for handle treatments because it complements the gray, crackled raku surface. Recently she began experimenting with sterling silver for spouts and handles, giving her teapots a clean, stylized look. ■ PAGE 175

■ **YVONNE FOX ARRITT**

Developing new applications for traditional techniques, Yvonne Fox Arritt creates serving pieces and table accessories that stress utility while expressing restrained whimsy. She creates modern versions of specific-use flatware of the 18th and 19th centuries, including asparagus tongs, shrimp forks and berry spoons. ■ PAGE 158

■ **KATHLEEN ASH**

Always intrigued by process, Kathleen Ash enjoys the technical challenges of working with glass. Her designs are clean, unselfconscious and often humorous, maintaining both functional and aesthetic value. ■ PAGE 31

■ **DAVID AVISON**

David Avison focuses on three main subjects — landscapes, cityscapes and people-scapes. His images, which are often complex, invite exploration, contemplation and discovery. Collections include: Art Institute of Chicago, IL; Museum of Modern Art, New York, NY; Museum of Fine Arts, Boston, MA; International Museum of Photography, Rochester, NY. ■ PAGE 84

■ **LIZ AXFORD**

Liz Axford works "quasi-improvisationally," creating order and a sense of procession with her hand-dyed fabrics. She draws a rough sketch of each quilt and pulls a basic palette of fabric from her stack, dyeing more fabric if needed. Her creations successfully blend order and improvisation, linearity and the element of surprise. ■ PAGE 50

■ **POSEY BACOPOULOS**

Posey Bacopoulos throws, alters, handbuilds, and assembles terra cotta vessels. Her final step is applying a majolica glaze — smooth, white and opaque. Then she applies a thin wash of colorants to the glazed surface to create the decoration. After firing, the glazed surface maintains the line quality and color of the decoration. Throughout this process, Bacopoulos strives for lively expression of line, pattern and color. ■ PAGE 62

■ **BORIS BALLY**

Boris Bally recycles street signs and bottle caps to create furniture and bowls that are as tactile and beautiful as they are strong and unique. Collections include: Victoria and Albert Museum, London, England; Smithsonian Institution, National Museum of American Art, Washington, DC; American Craft Museum, New York, NY; Mint Museum of Craft + Design, Charlotte, NC. ■ PAGES 149, 159, 191

■ **LYNN BASA**

Lynn Basa has been investigating fiber as an artistic medium for the last 30 years. She is known for both her small-scale tapestries and her exploration of the symbolic and narrative potential of rugs as art form. Collections include: American Craft Museum, New York, NY; SAFECO Insurance Co., Seattle, WA. ■ PAGE 109

■ MICHAEL BAUERMEISTER

Objects he sees in nature and in cities inspire Michael Bauermeister's forms. His technique is influenced by his reverence for ceremony and tradition in craft. He makes up his own traditions as well to keep himself happy. ■ PAGE 45

■ KATHRYN BERD

Berd uses a rich, colorful palette that begins with red earthenware clay. After the form is thrown and trimmed on the potter's wheel, Berd uses stains, underglazes and paints to enliven its surface with playful yet sophisticated designs. ■ PAGE 160

■ TARLETON BLACKWELL

Blackwell's work juxtaposes richly textured surfaces with complex themes. Each composition begins with an idea that Blackwell explores on small bits of paper. Subsequent studies are developed, and eventually the entire painting is transferred to a large-scale canvas. ■ PAGE 197

■ CHRIS BOISSEVAIN & ERIC ZIEMELIS

San Francisco sculptors Eric Ziemelis and Chris Boissevain create sculptural objects of utility — from credenzas and cabinets to tables and chairs. Believing that furniture is a natural progression from sculpture, Boissevain and Ziemelis work toward a distillation of form with the goal of creating the classic designs of the future. ■ PAGES 178, 188

■ DANA BOUSSARD

Boussard combines painting, drawing and appliqué to form textural works of art. Cut and sewn layers give richness and depth, while symbols and narratives add detail to the already intricate surface. Collections include: Federal Reserve Bank of Minneapolis, MN; MCI/Worldcom Corporate Headquarters, Colorado Springs, CO; AARP Headquarters, Washington, DC; Wells Fargo Bank, Torrance, CA. ■ PAGE 87

■ MARCIE JAN BRONSTEIN

Marcie Bronstein works both in a traditional darkroom and in a digital darkroom. She paints, sprays or drips toners onto each print, often tinting the finished piece with watercolor paints. In her digital work, she "tones" and "paints" her prints in Adobe Photoshop. Collections include: National Museum of Photography, Brescia, Italy; Creative Photographic Center, Lewiston, ME; Nonstøck, Inc., New York, NY. ■ PAGE 167

■ MARK BRYAN

Mark Bryan's paintings — acrylics on wood panel — take the form of altars or icons, and are heavily influenced by the time he spent as a student in Los Angeles, where he was introduced to Chicano culture, Catholic and folk arts, and the Mexican Muralists. While his work is based on broad themes, it also encompasses personal experience. Collections include: Transamerica Corporation, San Francisco, CA. ■ PAGE 105

■ RICHARD BUCKMAN

Buckman uses traditional techniques as well as the latest in archival iris and digital printmaking technologies. He believes strongly that there's a place for new theories and media, despite the art world's bias toward traditional approaches to printing. ■ PAGE 100

■ CHRISTIAN BURCHARD

Christian Burchard turns his baskets when the wood is extremely wet, exploiting the wood's flexibility and allowing for the creation of exceptionally thin pieces. The baskets are allowed to dry freely, warping into whatever final shape they please. Collections include: Royal Cultural Center, Jedda, Saudi Arabia; Renwick Gallery of the Smithsonian American Art Museum, Washington, DC. ■ PAGE 4

■ MYRA BURG

Myra Burg produces innovative site-specific art, including custom *Quiet Oboes,* and architectural installations such as rolling, pivot and ark doors. Sizes range from tabletop to airplane hangar for freestanding, wall-mounted and aerial constructions. ■ PAGE 48

■ MICHAEL A. BURNS

Burns uses ironworking, stone carving, sculpture and jewelry-making techniques to produce each piece, bringing together all of his creative experiences to form sculptural furniture. "It is sculpture with a lid," he says, "it is jewelry set with stones." ■ PAGE 204

■ BARBARA BUTLER

Barbara Butler builds her furniture to fit its natural function and to be a simple but well-made canvas for her carving and staining. With their wooden handles, brilliant colors and sinuous carving, her pieces infuse their surroundings with warmth and light. ■ PAGE 129

■ ANTHONY M. BUZAK

Anthony Buzak pairs wood with exotic-looking veneers such as bird's-eye, quilted maple and pink satinwood. Some pieces also include ebony inlay. His favorite veneers are ones he has dubbed "freaks of nature" because the grain patterns are so unusual. ■ PAGE 44

■ ANN ALDERSON CABEZAS

Cabezas begins creating her forms by hand-blowing a hollow sphere of glass. She uses a sandblaster to remove unwanted areas to create dynamic and often realistic structures. Finally, colors are painted and fired onto the vessels. ■ PAGE 35

■ CAROLYN & VINCENT CARLETON

The materials Carolyn and Vincent Carleton use are all natural: worsted wools from Argentina, Belgian linen, leather. They work in a "summer and winter" double weave, creating rugs that are completely reversible and strikingly different on each side. ■ PAGE 72

■ WENDELL CASTLE

Wendell Castle, who is legendary for his functional sculpture and innovative use of wood, has inspired generations of furniture makers and artists around the world. Collections include: The White House, Washington, DC; Metropolitan Museum of Art, New York, NY; Museum of Fine Arts, Boston, MA; Art Institute of Chicago, IL; Renwick Gallery of the Smithsonian American Art Museum, Washington, DC; Mint Museum of Art, Charlotte, NC. ■ PAGE 135

■ SEAN CAYLER

Sean Cayler uses a hand-held grinder to form his mostly hollow pieces from blocks of undeveloped steel. He considers this to be the most artistic part of his endeavor — creating something out of nothing. Collections include: John Elder Gallery, New York, NY; Handsel Gallery, Santa Fe, NM; Meredith Gallery, Baltimore, MD. ■ PAGE 179

■ AMY CHENG

Amy Cheng has developed a painting vocabulary based in various cultures. Her oil works often rely on repeated patterns, brilliant color and an intricate layering of space. Her most recent works, while abstract, provide visual references to planets and stars, fabrics and maps. ■ PAGE 55

■ JOHN CHILES

Even-hued, symmetrical shapes characterize John Chiles's work. Clean forms adorned with discs, draping tubes and colorful handles are topped with dishes, spheres and flames, creating work that is bright and animated. ■ PAGES 13, 187

■ PHYLLIS S. CLARKE

Phyllis S. Clarke creates her vessels from soft, colorful glass, using sculptural and offhand techniques with a glassblowing torch. The kind of intimate relationship that she forms with each piece in the flame, she believes, is a path toward a higher level of understanding. Collections include: Bead Museum, Prescott, AZ; Folk Craft Museum, Toyola City, Japan. ■ PAGE 154

■ MARDI-JO COHEN

Function, design, color and fun are the elements most important to Mardi-jo Cohen in the creation of her metalwork. Collections include: American Craft Museum, New York, NY; Yale University, New Haven, CT; American Silver Museum, Meriden, CT. ■ PAGE 110

■ TIMOTHY COLEMAN

Timothy Coleman defines his furniture with richly textured surfaces and gracefully balanced forms. Using low-relief carving and thick veneer tiles, he customizes each piece with a variety of decorative effects. ■ PAGE 73

■ JEANNE CONTE

Jeanne Conte's subjects range from children, dancers and body-builders to landscapes, nudes and flowers. She is fascinated by how different the world looks through a lens and how perspective can give objects a whole new reality. All of her prints are done by hand in silver gelatin on fiber paper. ■ PAGE 101

■ PHIL CORNELIUS

Phil Cornelius is widely celebrated for his "thinware" or impossibly thin pots. Cornelius, who received his M.F.A. in 1960, has held a teaching position with Pasadena City College since 1965. One of the artist's most persistent forms has been the teapot, which he takes into the realm of non-functional sculptures resembling gunboats, planes, tanks, houses and abstract forms. ■ PAGE 118

■ ANTHONY CORRADETTI

Anthony Corradetti produces dense, overlapping patterns and colors by using glass luster paint on the surface of blown vessels. Each layer must be fused individually in an annealing oven, and each piece may be fired as many as 12 times. Collections include: White House Collection of American Crafts, Washington, DC; Renwick Gallery of the Smithsonian American Art Museum, Washington, DC. ■ PAGE 23

■ ROBERT COTTINGHAM

Robert Cottingham is internationally renowned as one of America's most important photorealist painters. Over the years he has worked in series: buildings, signs, words, numbers, letters, railroad imagery and typewriters. Collections include: Metropolitan Museum of Art, New York, NY; Museum of Modern Art, New York, NY; Solomon R. Guggenheim Museum, New York, NY; Art Institute of Chicago, IL. ■ PAGE 80

■ STEPHAN J. COX

After his blown glass forms cool. Stephan J. Cox shapes them with diamond sawing, high-pressure sand carving, wheel grinding, belt grinding and diamond-point carving techniques. Collections include: Corning Museum of Glass, NY; White House Ornament Collection, Washington, DC. ■ PAGE 32

■ **BARBARA CRANE**

Barbara Crane has worked with all photographic formats and materials, from platinum prints to large-scale, one-of-a-kind Polaroids. Collections include: Museum of Modern Art, New York, NY; Renwick Gallery of the Smithsonian American Art Museum, Washington DC; Getty Museum, Los Angeles, CA; Bibliotheque Nationale, Paris, France; National Museum of Modern Art, Kyoto, Japan. ■ PAGE 200

■ **LEAH KRISTIN DAHLGREN**

Dahlgren uses techniques of the Old Masters to obtain glowing color and luminosity. She begins with an underpainting, over which many thin layers of oil build the surface and bring the painting to life. The painting is finished with transparent glazes for added depth and radiance. ■ PAGES 149, 153

■ **ROBERT DANE**

Robert Dane's work revolves around the themes of life and growth. He manipulates glass into sculptural forms with a variety of techniques, including blowing and hot-working solid glass. Collections include: American Craft Museum, New York, NY; Philadelphia Museum of Art, PA; Corning Museum of Glass, NY; Glasmuseum, Ebeltoft, Denmark. ■ PAGE 157

■ **MARY DICKEY & MARTHA GLOWACKI**

Mary Dickey and Martha Glowacki's pieces are hand cast in bronze. They use only the most durable outdoor woods, such as reclaimed tidewater red cypress and ironwoods. Every step in their process — from carving a foundry pattern and making a sand mold to grinding down the rough spots — is executed with function and fine design in mind. ■ PAGES 75, 176

■ **FRANK DIENST**

By performing all the details of printing himself — from selecting the subject, processing the film, printing the negative to matting the print — Frank Dienst is able to completely control his vision of the wetlands of the American Southeast, especially Florida. Collections include: Melbourne Museum of Art, FL; Florida House, Washington, DC. ■ PAGE 202

■ **LESLEY DILL**

Lesley Dill is at the forefront of the trend in contemporary art of using visuals with language, lending an edge to their fusion by peeling away stereotypes to create a fresh and unique vision. Dill's mixed-media photographs, sculptures and wall assemblages focus on the human figure and evocatively portray aspects of the human condition. ■ PAGE 59

■ **JAMES DRAKE**

James Drake collaborated with Landfall Press on *Salon of Eternal Souls* and *Salon of a Thousand Souls*, a pair of four-color lithographs depicting haunted interior spaces, void of human habitation. Collections include: Corcoran Gallery of Art, Washington, DC; Birmingham Museum of Fine Art, AL; La Jolla Museum of Contemporary Art, CA. ■ PAGE 180

■ **MICHAEL EADE**

Michael Eade uses gold leaf in his paintings to recall early Christian iconography, incorporating elements of an acquired vocabulary including symbols and images collected from travels in the West and Near East. Collections include: Washington State Arts Commission. ■ PAGE 196

■ **PAUL ESHELMAN**

Eshelman's pottery begins with drawings he's done of the things surrounding him — rural sheds, storage bins, roof angles, plumbing pieces, boats. He carves each form in plaster, making a mold from which he makes clay vessels. The finished pieces echo the smoothly polished surfaces of the plaster, creating the kinds of elegant, functional objects that he admires. Collections include: Ceramics Monthly, Columbus, OH. ■ PAGE 63

■ **AMY K. FAUST**

Amy Faust's pieces are created one at a time using hand-rolled sterling silver or gold to create a soft, "sandy" texture. The glass used in her work is derived from many sources — beach glass found on the northern California coastline, new and antique bottles with interesting bas-relief, and handmade stained glass. ■ PAGE 29

■ **JOHN FOSTER**

John Foster's ceramic pieces begin as whole forms, which Foster covers with white terra sigillata and burnishes. After they've been fired, he breaks them into fragments and colors the disassembled pieces individually, using a flashing or raku technique. He then reassembles them into designs of contrast and complexity. ■ PAGE 39

■ **NORMAN FOSTER**

Norman Foster directly applies pigments to his own formula of waxes and oils, blending them to create the expressive hues found in his finished paintings. Using a large variety of brushes and other tools, he works directly on board and linen canvas. ■ PAGE 2

■ **ROBERT GARDNER**

Gardner's thoughtfully conceived mixed-media constructions alter how we look at everyday objects. His recognizable cast glass shapes question function, celebrate form and revitalize weary spirits. ■ PAGE 121

■ JOHN GLICK

Instinct, intellect and openness to change are driving forces in potter John Glick's approach. Attracted to both simplicity and complexity, Glick is continually reexamining how these two opposites can coexist in a given series. Collections include: Renwick Gallery of the Smithsonian American Art Museum, Washington, DC; American Craft Museum, New York, NY; Los Angeles County Museum of Art, CA. ■ PAGE 62

■ BEN GOLDMAN

Familiar and disconcerting, provocative and paradoxical — Ben Goldman invents a world of juxtapositions in his dreamlike narratives. Pulling ideas from such varied sources as Japanese ukiyo-e prints and newspapers, nature calendars and crime photos, the painter provides a humorous look at contemporary visual bombardment. ■ PAGE 90

■ BARRY GORDON

Whether working from rough-sawn lumber processed at a sawmill or from large irregular chunks taken directly from the tree, Barry Gordon uses basic wood-shaping methods to create his utensils. He works alone, producing functional tools for preparing and serving food, as well as unique spoons built as decorative objects. His lifelong affection for tools and his ever-increasing fascination with wood produce memorable results. ■ PAGE 173

■ KATHERINE GRAY

Katherine Gray has always loved and respected glassblowing traditions and their applications. Though the processes present formidable challenges, she relishes the opportunity to skillfully decorate and ornament her glasswork. ■ PAGE 51

■ MICHAEL GRBICH

Michael Grbich is inspired and driven by the process and the physical and emotional act of creating. Grbich's abstract paintings and mixed media sculptures are developed with the aid of an unknown force that guides his hand in a search for expression. This ability to trust his feelings and emotions translates into compelling, ambiguous, meaningful imagery. ■ PAGE 139

■ DON GREEN

Don Green works with domestic and imported hardwoods and veneers, old-fashioned milk paint, steel and brass. Incorporating bold contemporary lines and colors into the elegance of traditional forms, he manages to create a distinctive style without sacrificing utility. ■ PAGE 130

■ PETER GREENWOOD

Peter Greenwood is continually motivated to explore the endless possibilities of working with hot glass, including various relationships in form, pattern and color. Collections include: American Craft Museum, New York, NY; Mint Museum of Craft + Design, Charlotte, NC; Hunter Museum of Art, Chattanooga, TN; Minnesota Museum of Art, St. Paul, MN. ■ PAGE 16

■ ANDREW GREGG

Andrew Gregg constructs *Bike Chairs*™ with a welded or mechanically fastened aluminum or steel frame made from recycled bicycle rims, frame tubes and handlebars. Upholstery materials range from inflated bicycle inner tubes and tires to seat belt webbing and leather. ■ PAGE 189

■ CHRIS GUSTIN

Chris Gustin's pots reference the body, using surfaces that purposely encourage a tactile interaction with the user. Collections include: Los Angeles County Museum of Art, CA; Victoria and Albert Museum, London, England; Mint Museum of Art, Charlotte, NC. ■ PAGE 36

■ ANNA GUZEK

Anna Guzek's serving pieces are constructed primarily of acid-etched sterling silver of varying surface textures and lengths; some feature anodized aluminum and niobium. Each piece within the collection is entirely hand wrought. ■ PAGE 172

■ CAT GWYNN

By giving familiar scenes the attention of her lens, Cat Gwynn stresses details that would otherwise remain blurred by the busy commotion of their surroundings. Gwynn's painterly approach to photography lends itself to keen and often humorous observations. ■ PAGE 178

■ HENRY HALEM

Henry Halem works to redefine the nature of conceptual glass art, as his sculptures and vessels push the limits of their material's bounds. Halem's thought matches the spectrum of his techniques and materials: vitreous glass enamels, glass castings, glass cutouts and precious leaf. Collections include: Smithsonian Institution, Washington, DC; Corning Museum of Glass, NY; High Museum of Art, Atlanta, GA; American Craft Museum, New York, NY. ■ PAGE 122

■ BOB HAWKS

Bob Hawks has developed his own techniques for creating complex segmented pieces that incorporate multiple geometric patterns and several red and yellow toned woods from Brazil. He creates subtle forms, turned from solid pieces of Norfolk Island pine from Florida and several other varieties of local (Oklahoma) woods. Collections include: The White House, Washington, DC. ■ PAGE 141

■ SHARON HEIDINGSFELDER

Sharon Heidingsfelder's quilts involve complex graphic shapes. While one block design is repeated throughout, it is often obscured by turning every other block upside down, revolving the blocks around themselves, or placing blocks in an unexpected grid. When it comes to color, Heidingsfelder relies on intuition by witnessing the effect each block has on the entire quilt. ■ PAGE 79

■ JERI HOLLISTER

Jeri Hollister's sculptures begin with long hollow extruded shapes and wheel-thrown forms. She cuts, tears, and reassembles the thrown and extruded parts to form legs, haunches, shoulders, belly, neck and head; larger pieces are built in pieces. Finally, the parts are assembled and glued after the clay has been glazed and twice fired. Her goal for each sculpture is to convey how it evolved and the energy involved in building it. ■ PAGE 119

■ CAROL HOPPER

Carol Hopper concentrates on strong composition and design elements in her charcoal drawings. As she works, she moves from light to dark and from hard lead to soft. Cross-hatching and layering the different degrees of lead while using a kneaded eraser to soften or lift the pencil marks, she constantly refines each drawing. ■ PAGE 181

■ LINDA HUEY

Fascinated by clay's potential to express the forces of the natural world, Linda Huey collects leaves, sticks, flowers and seed pods for her ceramic shapes. Collections include: International Museum of Ceramic Art, Alfred, NY; Fidelity Investments, Smithfield, RI. ■ PAGE 34

■ SHUJI IKEDA

Shuji Ikeda weaves with clay. Once he realized that weaving ceramic baskets was what he wanted to do, the next step was to develop the ideal glaze. Over time he tested more than 100 and chose one to refine, naming it Sei Shya, or "blue rust." Collections include: Unocal Corporation, Los Angeles, CA; Duke Energy Corporation, Houston, TX. ■ PAGE 65

■ CHRIS IRICK

Inspired by industrial architecture, Irick uses die forming and casting to give her boxes, lockets and other metalwork full, rounded shapes. Doors and lids open onto passages created in perspective, while surface treatments such as etching and patination are used to strengthen the sense of age. ■ PAGE 77

■ KIYOMI IWATA

Elements from the aesthetic of her birth country are apparent in Kiyomi Iwata's fiber vessels, including clear structural designs and a reverence for packages and wrapping. In addition, silk and metal leaf are employed as in the creation of kimonos. Collections include: Metropolitan Museum of Art, New York, NY; Renwick Gallery of the Smithsonian American Art Museum, Washington, DC. ■ PAGE 46

■ LISA JACOBS

Lisa Jacobs forms all of her work by hand, letting the hammer's marks and joinery show through in an approach to furniture that leaves the function unimpaired. Hammering hot steel into sleek curves, Jacobs makes stiff, cold raw materials come alive with her whimsical manipulations. Each piece has an unexpected line or surprising curve that catches the viewer off guard. ■ PAGE 134

■ JULIA JACQUETTE

Julia Jacquette creates paintings about notions of romance, desire and elegance. Her images of clichéd food dishes from the 1950s, juxtaposed with erotic phrases that play on common culinary adages, are playful and provocative metaphors for the relationships between eating, sexuality and femininity. ■ PAGE 150

■ JARED JAFFEE

Jared Jaffee chooses to work with the traditional teapot form because of the possibilities for artistic expression within a functional formation. But Jaffee constructs forms in ways that are unusual for conventional teapots. The elements interact with each other and the viewer by creating different sets of imageries, often with a humorous inflection. ■ PAGE 16

■ CATHI JEFFERSON

Cathi Jefferson finds endless inspiration in the natural setting of her studio. She works to capture the sun's reflection through a raindrop, the deep red tones and textures of the rock cliffs, the strength of an old cedar. ■ PAGE 164

■ DONALD JUDD

As an internationally renowned sculptor, art critic and minimalist, Donald Judd took questions of good design with great seriousness. Judd's furniture, first made exclusively for his own use, was eventually put into production. By the time of his death in 1994, he had created 94 designs. Collections include: Solomon R. Guggenheim Museum, New York, NY; Whitney Museum of American Art, New York, NY. ■ PAGES 71, 178

DONGJOO KANG-SUH
The artwork of Dongjoo Kang-Suh details her interest in the correspondence of shapes. Using slabs and plaster molds with slab or slip casting, Kang-Suh determines her approach by the design of each particular piece. ■ PAGE 171

BERNARD KATZ
Bernard Katz designs and executes each piece using a combination of modern equipment and ancient technique. His blown vessels become three-dimensional canvases for his designs. After encasing a vessel in layers of crystal and a darker color, he slowly removes layers of glass to realize the image within. ■ PAGE 88

ROBERT KEHLMANN
Robert Kehlmann overlays hand-blown, sandblasted glass onto mixed-media and charcoal drawings on board. He sandblasts the back surface of hand-blown glass to graphically link the glass with an underlying drawing. Collections include: American Craft Museum, New York, NY; Corning Museum of Glass, NY; Hokkaido Museum of Modern Art, Sapporo, Japan. ■ PAGE 18

LINDA KELLY
Linda Kelly makes large-scale sculpture woven from reed. Inspired by the human form, the simple shapes of her sculpture resemble figures, whether poised in conversation or hovering overhead. Because the fiber medium does not limit ultimate size, Kelly's forms can be as large as 6' tall. ■ PAGE 47

KIM KELZER
Whether drawing her designs from fashions seen on television, in advertisements or throughout clothing stores, Kim Kelzer creates her furniture by playing with texture, shape and color. Using traditional joinery to construct her work, Kelzer finishes the surfaces with unconventional techniques. Collections include: Museum of Fine Arts, Boston, MA; Children's Museum, South Dartmouth, MA. ■ PAGE 115

BRIAN T. KERSHISNIK
Brian T. Kershisnik welcomes the influence of children, artistic greats and cave paintings in his oil-on-paper and panel works. He allows experimentation and inspiration to guide his open-ended images. Collections include: Springville Art Museum, UT; Delta Airlines; Museum of Church History and Art, Salt Lake City, UT. ■ FRONT COVER, PAGE 108

DAVID KIERNAN
Working primarily with wood — maple, sycamore and mahogany — Kiernan uses metal as an accent material. Discovering new materials and methods provides Kiernan with constant inspiration. ■ PAGE 192

JOHN KING
Painting on watercolor paper coated with gesso, John King seeks to infuse his textured and vibrantly colored landscapes with humor. His figurative studio work focuses on what he terms "social surrealism." ■ PAGE 104

MARK KOBASZ
Mark Kobasz creates his work by ladling molten glass into a sand mold. Doorways and windows are made by including carved blocks of hardened sand. Colors are achieved by sifting layers of powdered colored glass into the mold prior to the casting. ■ PAGE 199

JANE KRENSKY
Using a wide-angle lens, Krensky is as at home prowling the neighborhoods of Paris, New York and London as she is driving America's back roads and campgrounds in search of her subjects. A professional photographer for more than 25 years, she continues to travel, searching for the photographs that define our human frailties. ■ PAGE 97

KAREN KUNC
Karen Kunc creates large, multicolored woodcuts, which depict abstracted landscape and seascape elements. Her unique style of woodblock printing results in a wide range of color effects, from dense saturations to veil-like areas of thin shades. Collections include: Museum of Modern Art, New York, NY; National Museum of American Art, Smithsonian Institution, Washington, DC; Alvar Aalto Museum, Jyväskylä, Finland. ■ PAGE 57

ROBERT LANDAU
Robert Landau has been photographing the contemporary California landscape for the last 20 years. He does not manipulate the camera image. He uses composition and point of view to bring an original slant to his work. ■ PAGE 81

JACK LARIMORE
Sculptor and furniture maker Jack Larimore aims for the kind of authenticity that comes automatically in nature — beauty that doesn't strive to be but simply is. Larimore strives to capture and express this kind of honesty in his art. Collections include: Philadelphia Museum of Art, PA; Pennsylvania Convention Center, Philadelphia, PA. ■ PAGE 143

LYNN LATIMER
Each of Lynn Latimer's glass pieces begins as a sheet of translucent or opaque black glass that has been iridized to colorfully reflect light. She carves into the glass by sandblasting, adding details with a diamond-tipped tool. The carved sheets are placed over a curved form and slowly heated in a kiln until the glass softens and slumps into the contours of the mold. ■ PAGE 42

SILVIA LEVENSON

Silvia Levenson's work is about the tensions in everyday life. In recent pieces, the Argentine-born glass artist explores the feminine world of fashion — objects that besiege the affective life of women. Collections include: Altare Glass Museum, Altare, Italy; Glasmuseum, Ebeltof, Denmark; Musée du Verre, Sars Poterires Glass Museum, France. ■ PAGE 111

ROBERT LEVIN

Robert Levin seeks to capture the elements of elegance, fluidity, and whimsy in his work. He formulates his own glass, preferring opaque glass or frosted surfaces that emphasize the overall form of each piece. Collections include: Corning Museum of Glass, Corning, NY; High Museum of Art, Atlanta, GA; Contemporary Glass Museum, Madrid, Spain; Glasmuseum, Ebeltoft, Denmark. ■ PAGE 146

WALTER LIEBERMAN & JAMES MONGRAIN

Walter Lieberman joined forces with James Mongrain to develop a glass that not only floats but keeps beverages cool. Their *Swimming Champagnes* are made using only Venetian glassworking techniques, and embody the best in aesthetic and sculptural values. ■ PAGE 156

GREGG LIPTON

Lipton uses intuition as his primary guide in creating his innovative furniture designs, which combine utility and grace. In its concern with form, line, shadow and proportion, Lipton's work ultimately reflects a respect for the past while reaching for the future. ■ PAGE 66

BRUCE MACDONALD

Bruce MacDonald is committed to creating objects and furniture of visual delight. His work is fashioned from the "optimal" materials: 24K gold plate, stainless steel, aluminum, patinated brass and copper, glass, chrome and oven-cured powder paints. ■ PAGE 41

ELIZABETH MACDONALD

Elizabeth MacDonald presses clay slabs into powdered pigment, tears them into squares, fires them and assembles them into compelling mosaic images. Through this process, she is able to use color in a way that satisfies her need for spontaneity and surprise, accomplishing both delicacy and crustiness. ■ PAGE 8

ANNE MARCHAND

Anne Marchand's abstract paintings resonate with movement and energy. An accomplished colorist, she is recognized for her lyrical and musical compositions. Through her layering technique, Marchand paints a rich tapestry of textured surface and vibrant hues. Collections include: Kennedy Center, Washington, DC; Media One, Washington, DC; US Trust, Washington, DC. ■ PAGE 112

PAUL MARIONI

Paul Marioni has a surrealist's attitude. He works with glass for its distinct ability to capture and manipulate light, to create an illusion of motion or three-dimensionality in a two-dimensional plane. Marioni spends many hours painting each image and blowing the glass slowly and evenly. ■ PAGES 19, 114

RICHARD MARQUIS

In the early 1970s, Richard Marquis spent a year at the Venini factory in Italy, learning traditional Venetian glassblowing techniques. The fine filigree and lace-patterning of Venetian glass still characterize his work, which is otherwise thoroughly modern — and highly prized by collectors worldwide. ■ PAGE 30

LAURA MARTH

Laura Marth distills moments and ideas into visual sentences with diction that is determined by universal symbols and a vocabulary evolved from her past. Whether overtly or secretly, consciously or unconsciously, form, color, ideas and technique all work together to communicate. Color plays an enormous role in Marth's work and is chosen very deliberately for the role of its emotional impact. ■ PAGE 155

WENDY MARUYAMA

Rather than treating furniture as traditional objects of utility, Wendy Maruyama links each piece with human emotion. By combining colors and contrasting veneers, she gives her work a sense of character and autobiography. Collections include: American Craft Museum, New York, NY; Mint Museum of Art, Charlotte, NC; Oakland Museum of Art, Oakland, CA. ■ PAGE 70

MARIE MASON

Working with acrylic paint on canvas and paper, Marie Mason begins each painting with a large washed area on the soft, toothy canvas she has prepared herself. Mason's painting is experiential. Anything can suggest itself as the subject of her next work — a color, a movement, a mood or even the change of seasons. ■ PAGE 145

MICHAEL MCAREAVY

Michael McAreavy works solely with the Cibachrome printing process, preferring it for its brilliant color saturation and high image sharpness. A self-taught photographer, he creates emotionally charged scenic landscapes. Collections include: Johnson & Johnson, New Brunswick, NJ; Opel Bank, Leipzig, Germany. ■ PAGE 203

GAIL MCCARTHY
To accomplish the rare colors found on her lustered vessels, Gail McCarthy combines ancient Persian alchemy with contemporary ceramic techniques. Her clay forms are spun on the wheel and sheathed with blazing-hot copper reds, molten golds, flashing ocean-blues and liquid silver, which she imprisons within satin-smooth or crusted lava surfaces. ■ PAGE 123

JOHN MCDERMOTT
With its innovative combination of wood, metal, stone and glass, John McDermott's furniture reflects his background in both engineering and art. Using domestic hardwoods found in the mountains of North Carolina, McDermott personally selects the choicest logs, then mills and dries them in a specially constructed kiln. ■ PAGE 190

ROBERT & CHRISTIAN MEIER
The Meier brothers work to achieve an exciting look, crafting tables and other furniture from both domestic and exotic woods. These identical twins, born in Munich, Germany, obtained their master's degrees in mechanical engineering, then studied the classic techniques of fine woodworking and finishing at Munich's University of Art. ■ PAGE 131

RICK MELBY
Rick Melby often recycles 20th-century memorabilia into pieces that articulate a hybrid viewpoint. The result is a type of "post-millenium folk art for the culturally saturated." Collections include: Daiwa Corporation, Japan; Edge Publishing, New York, NY; Dun & Bradstreet, Murray Hill, NJ. ■ PAGE 20

GEORGE THOMAS MENDEL
George Thomas Mendel documents beautiful moments that most people overlook. Whether presenting waterscapes, florals, architecture or portraits, each of his photographs reveals a glimpse of his artistic viewpoint. All of his work is printed using traditional processes and materials that go back to photography's beginnings. ■ PAGE 201

DIMITRI MICHAELIDES
Dimitri Michaelides's brightly colored opaque vessels are made from individually crafted glass elements — birds, handles, polka dots and flames — attached to the blown form with a small bit of hot, clear glass. Though the shapes are reminiscent of those of ancient vessels, their striking colors secure their place in the modern age. ■ PAGE 126

ROGER MINICK
Roger Minick builds each series of photographs around the distinct character of a given place, shedding light on the often-buried history, culture and politics of the people and land. Collections include: Getty Museum, Los Angeles, CA; Los Angeles County Museum of Art, CA; Metropolitan Museum of Art, New York, NY; Renwick Gallery of the Smithsonian American Art Museum, Washington, DC. ■ PAGE 182

NANA MONTGOMERY
Nana Montgomery considers a quilt's surface to be a canvas for her paintings in fabric. She begins by constructing her quilts in a traditional manner, applying paints and other embellishments after each quilt is constructed to enhance its surface design. ■ PAGE 184

JUDY MOONELIS
Judy Moonelis's contemporary portraits are individually modeled directly from life in clay. She seeks to capture a vivid quality of a living human being, and something of their inner workings at a specific moment in time. Collections include: Renwick Gallery of the Smithsonian American Art Museum, Washington, DC; American Craft Museum, New York, NY; Mint Museum of Craft + Design, Charlotte, NC. ■ PAGE 61

DAVID MOOSE
David Moose's works are oil on stretched canvas or textured wood panels. His abstract interests come into play as the forms of the landscape are edited, simplified or exaggerated to give them an iconographic "personality." Colors are often intensified to heighten the magic of the illusion. ■ PAGE 93

WILLIAM MORRIS
The glass sculptures of William Morris express his fascination with animal forms and primitive cultures. He is one of the most prolific and admired of contemporary glass artists. Collections include: Metropolitan Museum of Art, New York, NY; Louvre, Paris, France; Victoria and Albert Museum, London, England. ■ PAGE 82

M.L. MOSEMAN
M.L. Moseman's paintings focus on rural farm scenes. Using simplified compositions with strong light and color, he captures the ephemeral nature of agrarians at one with the land. Collections include: Sioux City Art Museum, IA; Kansas State Historical Society, KS. ■ PAGE 92

■ RALPH MOSSMAN & MARY MULLANEY

Ralph Mossman and Mary Mullaney are a husband and wife duo collaborating as equal partners in the production of each piece. Their partnership provides them with the coordination and grace required to create beautiful and technically complex work that evokes a sense of wonder through its intricate, delicate and precise use of pattern. Collections include: The White House, Washington, DC; Bead Museum, Phoenix, AZ. ■ PAGE 27

■ JACK MOULTHROP

Jack Moulthrop's ceramic pots are the result of his admiration of New World vessels indigenous to the Americas. His well-rounded ellipsoids and spheroids recall the even forms of their pre-Columbian ancestors. Necks, handles, lids, bas-relief, texture and designs are added as final decoration. Collections include: Ohio Craft Museum, Columbus, OH; Canton Museum of Art, OH. ■ BACK COVER

■ MARY MULLANEY

The process used to produce the cameo effect of Mary Mullaney's etched bowls starts with the layering of colored and clear glass. After the glass is blown into the bowl form, Mullaney draws and sandblasts the design. ■ PAGE 84

■ DENNIS NAHABETIAN

Using a technique he developed himself and calls "pizzicato," Dennis Nahabetian fabricates pieces in metal-mesh patterns that are all his own. His bracelets and arm ornaments are meant to be worn but can also function as objects of contemplation. ■ PAGE 76

■ MARLIES MERK NAJAKA

The simplicity of Marlies Merk Najaka's images enables viewers to picture what else could be on the kitchen table next to the bowl of cherries, or near the tomato vine in the garden. Collections include: Cooper-Hewitt National Design Museum, New York, NY. ■ PAGES 166, 177

■ LAURA FOSTER NICHOLSON

Textile artist Laura Foster Nicholson studied weaving at the Cranbrook Academy of Art. She enjoys working with domestic subjects to make even the most ordinary contents of a vegetable garden, pantry or tool shed into appealing works of art. Collections include: Cooper-Hewitt National Design Museum, New York, NY; The Minneapolis Institute of Arts, MN; Archives of the Venice Biennale, Venice, Italy. ■ PAGE 54

■ RICHARD OGINZ

Richard Oginz fabricates each cabinet from hardwoods. He stains and paints the wood to add color, cutting images into the surface as decoration. His long fascination with tribal art and its relationship to modern sculpture is the inspiration for his anthropomorphic cabinets. ■ PAGE 89

■ VINCENT LEON OLMSTED

By pouring molten glass into a sand mold, Vincent Leon Olmsted contrasts the natural seductiveness of polished glass with the rough surface of cast glass. A found object housed within each of his works serves as the starting point of a narrative, luring the viewer into the chronicle of each piece. Collections include: Rhone-Poulenc Rore, Inc, Collegeville, PA; Bonita Granite, Mullica Hill, NJ. ■ PAGE 185

■ MARKIAN OLYNYK

Markian Olynyk's complex screens are fabricated from 1/2" pieces of brilliantly colored tempered glass. Numerous techniques such as acid etching, texturing, polishing, lacquering and painting finish the surfaces of his intricate designs. ■ PAGE 85

■ LANEY K. OXMAN

As a potter, sculptor and painter, Oxman carefully blends techniques from each discipline in the process of creation. Each ceramic piece becomes a canvas for spontaneous composition, where color and brushstrokes are applied with unhesitant control. ■ PAGE 148

■ EMI OZAWA

By combining animal shapes with the formal elements of furniture, Emi Ozawa invites viewers to enjoy her work through hands-on participation — opening doors or drawers, turning latches, folding panels. ■ PAGE 193

■ JUDITH PALMER

Judith Palmer assembles found language as actors: photographs of construction information on streets and walls, printed dress patterns, discarded bits of paper. She then transfers these messages onto zinc plates through a photo-etching process and strives to generate a dialogue between the ready-made signs from "out there" and the language of her art. Collections include: Riverside Art Museum, CA. ■ PAGE 86

■ EUNJUNG PARK

Eunjung Park's unique teapots serve as a form through which to explore the metaphorical, functional and ritual connections between people and objects. Park takes forms from nature, such as fruits and vegetables, and reorganizes them into startlingly original compositions. ■ PAGE 63

■ SHIRLEY PASTERNAK

Shirley Pasternak uses only natural available light to photograph her still lifes. Originally a painter, Pasternak succumbed to a longtime attraction to black-and-white photography and is now completely devoted to it. Collections include: Hans-Christoph Beythan Corp., Luxembourg; Savoia International Corp., Rome, Italy; Hotel Unimonakamichi, Fukuoka, Japan. ■ PAGE 162

■ KAREN PERRINE

Karen Perrine begins with white fabric and adds color through dyeing techniques such as immersion, dipping, direct application and stamping. Some of her quilts are formed from pieced and painted cotton fabrics. Others are whole cloth, with the entire design painted on one piece of yardage. Collections include: Yoshizawa Hospital, Tokyo, Japan; City Hall, Kirkland, WA.
■ PAGE 106

■ LINDA S. PERRY

Linda S. Perry designs the surfaces of much of her fabric herself — hand dyeing, printing and marbling cottons and silks, and incorporating metallic leaf and paints. Inspired by Italian frescoes and Japanese design, she aims for a painterly effect in her quilts. Collections include: White House Ornament Collection, Washington, DC; American Embassy, Caracas, Venezuela.
■ PAGE 52

■ PETER PIEROBON

Each of Peter Pierobon's pieces is carved, sanded and finished entirely by hand. By combining contemporary styling, traditional craftsmanship and the ritualistic use of decorative elements, he produces a distinct balance between the primitive and the sophisticated. Collections include: American Craft Museum, New York, NY; Mint Museum of Craft + Design, Charlotte, NC.
■ PAGE 69

■ BRUCE PIZZICHILLO AND DARI GORDON

Dari Gordon and Bruce Pizzichillo are influenced by forms and patterns observed in nature and during their travels. While the artists make use of found objects and recycled materials for their mixed media sculpture, they utilize Italian glassworking techniques when working with glass. Their goal is not to blow traditional Italian glass, but to use the techniques in their own modern way, updating them to suit their needs. ■ PAGE 198

■ STEPHEN ROLFE POWELL

Stephen Powell uses form and texture to guide the creativity required to shape his large vessels. Thousands of murrini are used to design the unique surface pattern of each piece. Collections include: Charles A. Wustum Museum of Fine Arts, Racine, WI; Cleveland Museum of Fine Arts, OH; Detroit Institute of Arts, MI. ■ PAGE 127

■ JANUSZ POZNIAK

Janusz Pozniak's glass pitchers, vases, bowls and candlesticks are inspired by impressions of people and recollections of events. As the work develops, the objects become autonomous, with endless representational possibilities. ■ PAGE 186

■ GEORGIA & JOSEPH POZYCINSKI

Georgia and Joseph Pozycinski have worked as sculptors in various media since the mid-1970s, but now work exclusively in bronze. Their collaborative designs are a combination of two very different energies, creating work that helps define man's relationship with nature in the next millennium. ■ PAGE 205

■ PAUL RAHILLY

Paul Rahilly's oil paintings are visual explorations in which the medium conveys the message. Although there is a strong image present, the paintings are as much about paint as they are about image. Each area of the painting is treated as a painting in itself, with its own space, color and surface independent of the object represented. ■ PAGE 96

■ KEITH & VALERIE RAIVO

Piles of domestic hardwoods fill Keith and Valerie Raivo's shop. Oak, elm, walnut, ash and cherry are cut into thin planks and sorted; only wood with straight grain and no defects finds its way into their baskets. Their work is held together with square-shanked copper nails, with the end results as functional as they are durable. ■ PAGE 67

■ BOB RASHID

Bob Rashid's roots are in journalism, so his camera technique is to respond to what he sees and feels. Landscapes are his passion, and through his work he strives to reflect the beauty of nature. Collections include: Wisconsin Arts Board, WI; Miller Art Museum, Sturgeon Bay, WI. ■ PAGE 183

■ VICKI REED

Vicki Reed's goal is to create an image that can transport her viewers to the moment in time when the photograph was made. What she enjoys most about creating her handcolored images is that she doesn't need to rely on color film to tell her what she saw — she has the freedom to rely on the image and mood that were recorded in her memory. ■ PAGE 103

■ ANN A. RHODE

Ann Rhode begins her quilts with a basic block structure and then rotates the blocks to establish pathways for the eye to follow. Her quilting lines assist the eye in seeing three-dimensional images. She pays close attention to the mood suggested by various colors as well as their value and intensity as she combines fabrics into layers of expression. ■ PAGE 53

■ **HOLLY ROBERTS**

Holly Roberts uses her own black-and-white photographs as a ground for heavily painted, etched, scraped and smeared images. Collections include: Art Institute of Chicago, IL; Museum of Photographic Art, San Diego, CA; Phoenix Museum of Art, AZ; Los Angeles Museum of Contemporary Art, CA; San Francisco Museum of Modern Art, CA; Museum of Fine Art, Houston, TX. ■ PAGE 60

■ **JAMIE ROBERTSON**

Jamie Robertson prides himself on impeccable craftsmanship: the handles fit your fingers "just so" and the doors whoosh as they open. Each of his pieces redefines the distinction between craft and art, between the exclusive domains of function and aesthetics. Collections include: Pritam & Eames, East Hampton, NY; Society of Arts and Crafts, Boston, MA; SANSAR, Washington, DC. ■ PAGE 6

■ **ANN ROBINSON**

Ann Robinson transitioned from glassblowing to full-time casting after moving to the west coast of Auckland several years ago. Her work has developed in relation to this wilder and more expansive environment, where she creates glass sculpture and vessels using a modified form of cire perdue, or lost wax casting. ■ PAGE 22

■ **PEET ROBISON**

Peet Robison's innovative use of glass powders, shards and threads captures the colors and transitory light of New Mexico's sunrises and sunsets. The addition of a reactive silver glass formula produces a unique surface luster that is unrivaled in contemporary glasswork. ■ PAGE 107

■ **CHRISTINE RODIN**

Christine Rodin likes the sensuality of light — how it quietly reveals the simplest curve of a bowl or the smallest thread of an old cloth. Flowers, fruit and porcelain populate her images, set in a still, softly lit environment. By sepia-toning her black-and-white photographs, Rodin hopes to add a sense of timelessness and feeling to ordinary objects. ■ PAGE 168

■ **SETH ROLLAND**

Seth Rolland creates exquisite, organic furnishings built to last for generations using primarily American hardwoods. As a concerned environmentalist, he obtains his wood from forests known to be sustainably harvested. Every piece of wood is selected for color and grain, then bent, laminated and carved into a graceful work of art. ■ PAGE 142

■ **LINDA ROSS**

Linda Ross creates molds in plaster and wax that retain some memory of the original object. By combining and altering these molds, she casts them in glass to create pieces with surprising and unlikely narratives. Collections include: Corning Museum of Glass, NY; Museum Haus Kasuya, Yokosuka, Japan; Musée des Arts Décoratifs, Lausanne, Switzerland. ■ PAGE 120

■ **WENDY ROSS**

Wendy Ross's airy, spatial constructions in steel defy the inert and industrial properties of the material. Although her work is distinctly sculptural, her techniques approach those of a textile artist: weaving, wrapping, and coiling materials into patterns and textures. Collections include: USA Today, Rosslyn, VA; National Park Service, San Francisco, CA; Kidder Peabody Corporation, Geneva, Switzerland. ■ PAGE 51

■ **BERNIE ROWELL**

By using unusual materials and innovative construction techniques, Bernie Rowell creates artwork that has both the tactile pleasure of a quilt and the longevity of an acrylic painting. Collections include: Hewlett Packard, Fort Collins, CO; MCI Worldcom, Columbus, OH; Mitsubishi Semiconductor America, Durham, NC. ■ PAGE 194

■ **GINNY RUFFNER**

Ginny Ruffner's glass sculptures are made using the process of lampworking, in which glass rods and tubes are softened over a flame and then bent into shape. Combining her education as a painter with her training as a lampworker, Ruffner sees her glass sculptures as canvases for her thoughts. Collections include: Metropolitan Museum of Art, New York, NY. ■ PAGE 124

■ **ALYSSA A. SALOMON**

Alyssa Salomon photographs found objects in front of constructed dioramas. Prints are made on Agfa Portiga paper, which she prefers for its warm rich qualities. The small scale and verticality of the prints are a direct reference to the antique cabinet card format. ■ PAGE 95

■ **JOAN SKOGSBERG SANDERS**

Joan Skogsberg Sanders's images are based on enigmatic reminiscences and evoke the strong religious thread that binds Morocco together. The paintings derive emotional content not only from Sanders's vivid recollections but also through the reworking and combining of juxtaposed images. ■ PAGE 102

■ **LAURA DE SANTILLANA**

Laura de Santillana's connection to the natural world and the realm of the senses lies at the heart of her subtle, Zen-inspired designs. Collections include: Museo Vetrario di Murano, Venice, Italy; Corning Museum of Glass, NY; Denver Art Museum, CO. ■ PAGE 43

■ RANDY SCHMIDT

The impetus for Randy Schmidt's work comes from real life events, pondering existence, or simply day dreaming. Schmidt, who has been a professor of art for 32 years, believes that art provides a method for raising questions — questions that need not to be answered so much as asked. Collections include: Pushkin Museum of Art, Moscow, Russia; Latvian Museum of Art, Riga, Latvia; Arizona State University Art Museum, Tempe, AZ. ■ PAGE 138

■ ARNOLD SCHWARZBART

Arnold Schwarzbart practiced architecture until 1981 and then began a career in Judaic art. He now creates functional ritual objects as well as Eternal Lights, Arks and Donor Walls for synagogues. His work has won awards in juried shows, is held in museum collections and can be seen in many synagogues.
■ PAGE 148

■ NANCY SELVIN

Nancy Selvin's handbuilt ceramic still lifes are investigations of process, studies of form and space and functionality as an illusion. Lines, silkscreened images or text are often added to her forms before firing. Collections include: Renwick Gallery of the Smithsonian American Art Museum, Washington, DC; Mint Museum of Craft + Design, Charlotte, NC; Los Angeles County Museum of Art, CA. ■ PAGE 56

■ OSCAR SENN

Oscar Senn works with oils on canvas. He begins each piece with an underpainting, usually in a color that contrasts with the overall tone of the piece. He uses thickened turpentine, which gives the paint the consistency of maple syrup. The motivation behind his paintings has always been place and time — single moments of drama and mystery frozen in ambiguous action.
■ PAGE 91

■ KAETE BRITTIN SHAW

Kaete Brittin Shaw's artwork focuses on energy and relationships. Spiral vessels convey the archetypal energy source of the spiral, while her paired vessels are concerned with energy fields between individuals and the collective idea of relationship. Collections include: Renwick Gallery of the Smithsonian American Art Museum, Washington, DC; Mint Museum of Craft + Design, Charlotte, NC. ■ PAGES 17, 170

■ STEVEN SHORES

Steven Shores incorporates all types of mixed media into his paintings — everything from lace to gold leaf can be found buried in his work, with each element carefully chosen for the theme it conveys. In his *State Fair* series, he explores a person's reflections on a day at the fair and how they provide the backdrop for emblematic objects that stand out as modern icons in a world still deeply rooted in the past. ■ PAGES 144, 179

■ JOSEPH SHULDINER

Joseph Shuldiner has always been fascinated by the primal essence of shelter. He uses both vernacular and indigenous architecture as well as locally accessible materials to construct functional objects that are also a vehicle for artistic expression. It is important for him to gather the material for each lamp in its native habitat — for instance, willow from local canyons and eucalyptus from neighboring hills. ■ PAGE 132

■ NICHOLAS SIMILE

Nicholas Simile begins his work with references to fine art, design history and literature from the prehistoric age to the postmodern. In the finished piece the form is pure and the function clear, a combination of minimalism, practicality and cultural references that express his creative commitment to changing the way traditional objects look. ■ PAGE 68

■ JOSH SIMPSON

Josh Simpson's personal aesthetic and passion reside in the cosmic universe and the natural world. The magic and alchemy inherent in molten glass provide Simpson with the means to express the wonder and mystery of the universe. Collections include: Smithsonian Institution, Washington, DC; Corning Museum of Glass, NY; Sphere Museum, Tokyo, Japan; Museum of Fine Arts, Boston, MA. ■ PAGE 24

■ KARYL SISSON

At swap meets or antique stores Karyl Sisson finds and then hoards "manufactured items that generally relate to domesticity or the feminine persona." By interlocking these collectibles she creates sculptural forms. ■ PAGE 64

■ NANCY SLAGLE

Nancy Slagle uses traditional methods — raising, stretching, flat-sheet construction and die forming — as she creates balance and harmony in her volumetric work. The influences behind her jewelry range from personal memories to historical references, and translate into intimate pieces that welcome close inspection and contemplation. ■ PAGE 174

■ KIMBERLY SOTELO

Kimberly Sotelo is redefining the nature of rustic furniture by filtering it through the terms of contemporary design. By using willow sticks in place of materials such as metal, glass, plastic and milled lumber, she transforms the coldness of modern form into an inviting and warm design. Collections include: Celestial Seasonings, Boulder, CO. ■ PAGE 74

MICHAEL SPEAKER
Animal desks and businessmen in Faust-inspired situations are some of Michael Speaker's figurative subject matter. He glues tiles over three-dimensional forms to make whimsical sculptures with hidden functional elements, and works diligently to convey the essential elements of movement with lifelike animal anatomy and realistic clothing wrinkles. ■ PAGE 99

SAM STANG
All of Sam Stang's work is created using traditional European glassblowing techniques. Incalmo pieces involve joining sections of hot glass at the furnace. The murrini and cane pieces are made by first creating glass rods, patterned in cross sections. Once cooled and cut into thin pieces, they are reheated and fused together into a unified whole. ■ PAGE 33

JANE STERRETT
Jane Sterrett blends photographic imagery with paint to produce a vibrant collage style. Starting with photographs that have been transferred to archival paper, Sterrett interprets multiple images and then uses mixed media to bring painterly surface values into play. ■ PAGE 163

FRED STONEHOUSE
Fred Stonehouse draws his influence from the eccentric and anti-classical. Lovingly crafted, each of his images has the appearance of a long-lost votive object whose original meaning is familiar but just out of reach. Collections include: Milwaukee Art Museum, WI; Tacoma Art Museum, WA; Madison Art Center, WI. ■ PAGE 98

CAROLINE STREEP
Caroline Streep's passion for creating is expressed in the physical interaction between hand, materials and tools, as files, chisels, hammers and torches transform sterling and high-karat gold. Collections include: National Museum of American Jewish History, Philadelphia, PA; The White House, Washington, DC; Helen Drutt English Collection, Philadelphia, PA; Philadelphia Museum of Art, PA. ■ PAGE 28

RANDY STROMSOE
The history of Randy Stromsoe's craft is evident in his 30-year collection of silversmithing tools. Stromsoe continues to work in the tradition of past master silversmiths in the specialized areas of spout making, hand forging, hand raising, chasing and restoration as well as more "modern" techniques such as spinning. Collections include: Vatican Museum, Rome, Italy; The White House, Washington, DC; Mint Museum of Craft + Design, Charlotte, NC. ■ PAGE 40

RICHARD SWANSON
The vitality and rhythms of the natural world influence Richard Swanson's sense of form and how those forms relate in space. Swanson is constantly combining and simplifying to enhance movement, rhythm and unity. Collections include: Los Angeles County Museum of Art, CA; Eiteljorg Museum, Indianapolis, IN; Yixing Red Pottery Arts Factory #5, Yixing, China. ■ PAGE 38

BILLIE JEAN THEIDE
Billie Jean Theide's energies are directed at designing and fabricating objects in copper, brass, sterling silver, and aluminum. Her pieces are an autobiographical record referring to the nature of specific relationships, where ideally aesthetics, concept, and function become one. Collections include: American Craft Museum, New York; NY, Museum of Decorative Arts, Prague, Czech Republic; Evansville Museum of Art, IN. ■ PAGE 14

PETER R. THIBEAULT
Peter Thibeault weaves found objects, beautiful woods and diverse materials into accessible architectural follies that pulse with color. Whether each piece is in grand or diminutive scale, delicate details abound as it strives for its own iconic monumentality. ■ PAGE 161

CESARE TOFFOLO
Cesare Toffolo is a master of lampworked glass and is known throughout the world for the ease, speed and precision of his work. Born to a family of Italian glass men in Murano, Toffolo now focuses on traditional vessels that become sculptures populated by his famous *Small Figures*. ■ PAGE 151

DEBBIE TUCH
Beginning with either sterling silver or 18K gold that has been heated and refined to produce a golden tone with more depth and color, Debbie Tuch proceeds to form her pieces by casting and hand-fabrication techniques. Adding luminous pearls, intriguing garnets and dazzling Austrian crystal only heightens the drama of her clean designs. ■ PAGE 25

JAMES TURRELL
James Turrell has been developing an art concerned with light and our perceptions of light for the last 20 years. Collections include: Art Institute of Chicago, IL; Solomon R. Guggenheim Museum, New York, NY; Whitney Museum of Modern Art, New York, NY; San Francisco Museum of Modern Art, CA.
■ PAGE 58

KUKULI VELARDE

Previously a painter, Peruvian-born artist Kukuli Velarde encountered clay for the first time while studying in the US. She found an immediate connection through the material to the art she had been searching for. Velarde's sculpture comingles history and present-day realities through subject matter dealing with historical and political issues. ■ PAGE 116

RIMAS VISGIRDA

Rimas VisGirda draws inspiration for his imagery anywhere from popular culture to historical ceramic design. His work has changed considerably in the 30 years he has been creating pottery, evolving from simple, functional forms to the sophisticated, whimsical pieces he now produces. Collections include: Arkansas Art Center, Little Rock, AR; Belgium State Museum, Brussels, Belgium. ■ PAGE 37

VIVIAN WANG

Vivian Wang's approach to her clay sculptures is influenced by 25 years of fashion design: color, texture and decoration define her work. The figures in her sculptures are derived from her Asian roots and often carry extremely elaborate textile designs. ■ PAGES 117, 165

CAROL WARNER

Warner's metal vessels are hand forged from ingots of copper, then chemically aged to create the colors and textures of artifacts. As part of the aging process, the ingots are suspended in a solution that is electrically charged to "grow" copper in the same manner that corals and crystals are formed. The surface is patinated to create the rich color of an ancient object. Collections include: Charles A. Wustum Museum of Art, Racine, WI. ■ PAGE 3

JACK WAX

Jack Wax is head of the Glass Program at Illinois State University, Normal, IL. He has taught at the Rhode Island School of Design, Ohio State University, Philadelphia College of Art, Cleveland Institute of Art, Tyler School of Art at Temple University and Toyama Institute of Glass, Japan. His works have been exhibited at the Philadelphia Museum of Art, the Hokkaido Museum of Art, the Azabu Museum in Tokyo and the Corning Museum of Glass. ■ PAGE 21

DICK WEISS

Dick Weiss's technique is both classic and straightforward: design, cut, lead, putty, clean. His love for stained glass windows, blown glass vessels and paintings has defined his career and helps shape his delicate screens into small, moving walls of light. Collections include: Victoria and Albert Museum, London, England; City of Seattle, WA; Corning Museum of Glass, NY. ■ PAGES 26, 85, 114

NAOMI WEISSMAN

In her *Food Still Life* series, Weissman uses very grainy film, harking back to autochrome photography in both choice of palette and breakdown of color into grain. The effect is nearly pointillist, enhancing stillness, bringing out subtleties of color, creating a mood of quietude. ■ PAGE 169

GEORGE WESTBROOK

Many of Westbrook's 5-pound vessels begin as 60-pound chunks of rock. Westbrook began working with wood — building and repairing fine yachts and traditional boats and navigating the world in them. Inspired by an article in a woodworking magazine, Westbrook decided to try using lathe techniques with stone. He has now been turning alabaster on a lathe for 10 years. ■ PAGE 11

SALLY WETHERBY

Sally Wetherby employs painting and photography in her creative process using layers of oil paint, transparent glazes, lacquer and wax on wood panel to achieve a highly finished, beautifully crafted effect. Wetherby's work is widely exhibited and has earned numerous awards. Her paintings are included in many private, corporate and museum collections. ■ PAGE 152

MARGE WHITE

Marge White's use of specialty fabrics and a layered collage technique enable her to achieve a variety of visual textures and depth. Collections include: American Museum of Quilts, San Jose, CA. ■ PAGE 195

ERIC WOLKEN

Inspired by the world around him, both the natural and the man-made, Erik Wolken bases his furniture on the interplay of simple geometric shapes — the roofline of a building, the structure of a bridge, the shields of an African tribe. Wolken selects those ideas that have a personality, a sense of motion, and a purpose. ■ PAGE 133

RICK WRIGLEY

Rick Wrigley draws on his thorough understanding of the past to inspire his furniture. Influenced most recently by the Herter Brothers, Daniel Pabst and other designers of the late 19th century, he crafts his tables, chairs, mirrors and cabinets from exotic woods, inlays and veneer, respectful always of the place of historical design. ■ PAGE 128

YOSHIKO YAMAMOTO

Yamamoto prefers to use unusual minerals in her work, and often chooses partially unpolished stones for the unaffected simplicity of their natural state. All of her jewelry is entirely hand fabricated, crafted with the rich color of high-karat gold and rare stones. Collections include: Museum of Fine Arts, Boston, MA. ■ PAGE 10

■ ERMA MARTIN YOST

In her fiber pieces, Erma Martin Yost explores the significance of the hand as a powerful symbol of expression and communication. All of the imagery in her current series is drawn from the handprints and pictographs left on canyon wall by natives of the American Southwest. Collections include: American Craft Museum, New York, NY; World Trade Center, Port Authority, New York, NY. ■ PAGE 94

■ DANA ZED

Dana Zed intricately cuts copper and places it between sheets of glass, which she then fuses together into panels. Combining stone, wood, shell, gold leaf and other mixed-media elements, Zed creates nonlinear narratives, which emanate harmoniously from her glass palaces. Collections include: Oakland Museum, CA; Corning Museum of Glass, NY; Pacific Bell Executive Offices, San Francisco, CA. ■ PAGES 85, 136

■ LARRY ZGODA

Larry Zgoda is recognized for his innovative coupling of new design vocabularies with traditional stained glass as a contemporary architectural art. The refractive and reflective qualities of a wide range of glass materials are imaginatively engaged to create luminescent works of art. Collections include: TCF Tower, Minneapolis, MN. ■ PAGE 137